Wood

Wood

Materials for Inspirational Design

Chris Lefteri

RotoVision

A RotoVision Book
Published and Distributed
by RotoVision SA
Route Suisse 9
CH-1295 Mies
Switzerland

RotoVision SA
Sales and Production Office
Sheridan House
112–116a Western Road
Hove, East Sussex BN3 1DD, UK
Telephone: +44 (0)1273 72 72 68
Fascimile: +44 (0)1273 72 72 69
ISDN: +44 (0)1273 73 40 46
E-mail: sales@rotovision.com
Website: www.rotovision.com

10 9 8 7 6 5 4 3 2 1

ISBN 2-88046-645-8

Original series concept by Zara Emerson
Cover and original series design by
Frost Design, London
Wood design and layout by Lucie Penn
Indexing by Richard Raper Indexing
Specialists, Hove

Originated by Hong Kong Scanner Arts

Printed and bound in China by Midas Printing

Contents

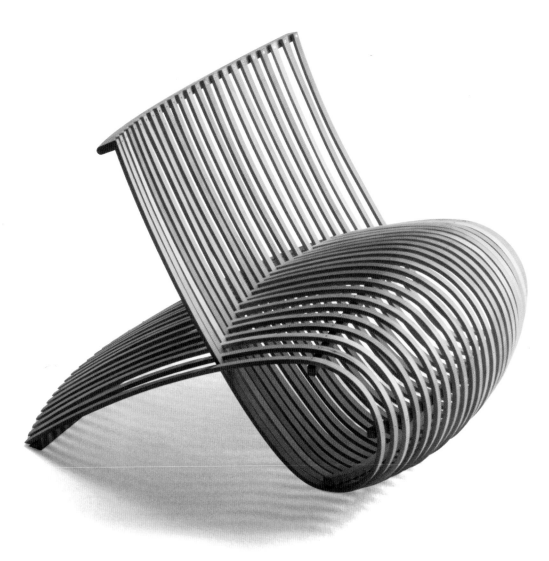

New technologies do not always lead to innovation in materials; new machines that extrude, mould, process, combine and convert are not necessarily the best examples of material use. It's not always the science of discovering new materials either. Sometimes it's the quiet, humble and intelligent projects that might ordinarily go unnoticed that reveal themselves to be the smartest. These designers offer us some of the most inspiring uses of materials because often they are the most sensitive and respectful of the environments in which they work and of the materials available to them.

The extruded chair on page 074 demonstrates new possibilities for wood, but there is more to this project than meets the eye. Not only does it provide a new production technique, it also draws attention to a process that uses waste to form a totally unique product. Bendywood™ and Flexywood™ (see pages 108 and 110) are further examples of this level of technology; normal timber has been transformed. This wood

Foreword

boasts new physical properties which, until recently, were associated with plastic rather than timber. These incredible advances in materials technology are liberating products from conventional production techniques and will continue to be discovered, evolved and developed.

However, it is easy to be impressed by remarkable new ways of transforming the physical characteristics of a natural material and to overlook projects that are less technology-led. Technology is always exciting, but today, as we become more and more conscious of the depletion of our natural resources, it is important to recognise and reward designers, craftsmen and manufacturers who respect and work towards sustainable uses of wood. Self-imposed restrictions offer examples of innovation and invention of the highest level. At Hooke Park in Dorset (see pages 098–099) round wood thinnings have been used for a local building project, thereby using a part of the tree otherwise wasted.

But there are still huge leaps to be made in our use of wood. Most wood production comes somewhere between pure technological innovation and intelligent resourceful projects. And it is this non-committal middle ground that leads to the biggest debates in timber use; there is no doubt that we need to eliminate wasteful by-products and excessive, indiscriminate felling of trees but unfortunately the politics are not that simple. The timber industry is truly global; specifying a particular wood in one country can have significant effects on large numbers of people elsewhere. Wood is dangerously exploited and yet so treasured at the same time; some of the cheapest and some of the most expensive products come from this one material. Thankfully, awareness of these issues is beginning to show as designers, architects and specifers are encouraged to make more informed decisions and take responsibility for the source of this fragrant bundle of cells that we have so long taken for granted.

Wood has an ability to bring out the designer in all of us. It's so accessible and easy to manipulate; it cries out to be shaped, carved, scratched, sanded and nailed. Many of us have sawn, cut or hammered into a chunk of wood as children, turning rough, abandoned pieces into all manner of toys.

Wood is one of the most widely understood materials; everyone can name at least a few different types. Oak, beech and teak, for example, are part of the language of consumerism and products are sold on the basis of their varying qualities. Consequently, wood brings out the material expert in all of us. Most of us, at some point in our consumerist lives, will choose a specific wood for that new living-room floor or dining-room table.

Different cultures have found incredibly diverse uses for every part of the tree. In China bamboo is used for scaffolding because of its flexibility in the tropical high winds. In Africa palm leaves are stripped down to their veins, dried and used as brushes for sweeping. Wood appears in countless forms: charcoal; building materials; cooking utensils; the book you are holding at this moment! It has to be one of the most used (and abused) materials available to us. It fulfils so many familiar functions in our daily lives that it often goes unnoticed. Yet the humble tree is a miracle of nature.

Until recently, wood had long reigned supreme as the material from which tools, weapons and vehicles were made. During the First World War ash was used in aircraft construction material. It was of such importance that an organisation was established known as the 'Ariel League' who approached landowners in the UK to buy and secure ash for use in aircraft manufacture.

The language of wood describes its qualities with a natural beauty without the need for additional surface decoration or marketing speak. The world is filled with species whose names are taken from these visual, physical and sensual clues, like Raspberry Jam wood, Snakewood, plum black, marblewood, ironwood, cottonwood, cheesewood, beefwood and blackbutt, for example. These evocative names not only give clues to their various characteristics but also add to the romantic allure of the material.

But it is easy to be romantic about wood. To be drawn into the traditions and values that it suggests, without considering the ugly side of modern wood production, is irresponsible. Unfortunately, wood is not unique in generating the greed and disrespect that go hand in hand with the love of any object or substance of desire. Large-scale deforestation and the destruction of massive areas of natural habitat and beauty continues in the name of profit and progress. However, the aim of this book, like Plastic and Glass before it, is not to debate the complicated pros and cons of using materials, but instead to present a range of products, materials and methods of production. Like all materials, the use of wood has its down side: yes, there is waste and, yes, a valuable natural resource is being depleted, but within these pages you will find numerous examples where both these issues have been addressed through finding intelligent and alternative uses for what would usually be considered waste material.

It is not too late for us to recognise and take steps towards a sustainable timber industry. Through well-managed and sustainable forests it is possible to produce wood for many uses. Wood has the natural advantage over many materials of being 100 per cent renewable. Also, it doesn't naturally produce any toxic by-products in its conversion from tree to product.

Plastic can be hip, glass can be cool, but wood commands too much respect to be in or out of fashion. Trees have one of the longest lifespans of all living forms – our oldest living trees are 5,000 years old. Wood was here long before we were and, if managed with the respect our natural resources deserve, will be here long after we are gone.

Preface

How to use this book

Wood offers an inspiring overview of many
types of wood and their derivatives, providing
information on a range of species and production
methods. This book continues the Materials
series by presenting the inquisitive reader with
a rich and unique introduction to wood. The core
chapters feature a range of projects, products
and processes looking at a diverse sample of
wood in various forms including well-loved,
classic designs, as well as showcasing innovative
new talent and previously unseen projects.

Each inspiring page or spread features a different
product or process. The accompanying text is
deliberately easy to digest, the idea being not
to swamp the reader with in-depth technical
knowledge but to inform in a common language
which hopefully suggests to the reader new ideas
for materials and products.

Further information pointers can be found in
the material properties section on each page.
However, the contact details given are intended

as a guide only and are by no means the only
source of the material featured. Arrow guides are
also included on most pages to cross-reference
relevant subject areas mentioned elsewhere.

The technical information section serves as a
reference guide to the main timbers in general
use today. Here you will find specific and detailed
information on woods with useful illustrations of
their colouring and grain. Ordering and buying
wood can be incredibly daunting so we have
included information on how to make a more
informed choice of timber in keeping with
sustainable practices. There is also a website
directory of key timber associations, suppliers
and environmental groups.

As with Plastic and Glass, the aim of Wood
is to offer a taste of the most interesting and
innovative materials out there. So please
browse, tuck in and enjoy some of the most
inspiring players and products in the world
of natural materials.

Ordering and buying wood can be daunting. Comparing the environmental benefits of building materials should take into account the environmental impact at all stages of the product's lifecycle, from extraction to final disposal. Timber has obvious advantages over other materials: it has the potential to regenerate and to provide an infinite supply for our use; wood is recyclable, waste efficient, biodegradable and non-toxic. It has also proven to be particularly energy efficient and can play a major part in combating global warming.

Can I specify sustainable timber?

A supplier may be able to provide evidence that timber derives from a 'sustained yield' source (ie from a continuous supply) and that forest management is effectively controlled and regulated. There can never be a guarantee of sustainability for the simple reason that there is no clear consensus on the definition of sustainability. However, independently certified timber that comes from forests audited under various multinational and national schemes is now available in small quantities from a number of different countries.

Are there any banned timbers?

Yes. They are listed under Appendix 1 of the Convention on International Trade in Endangered Species of Wildlife and Flora (CITES). Details of the CITES listing can be found on the Timber and Trade Federation's (TTF) Forests Forever Campaign link at www.ttf.co.uk.

Should I boycott other species, for example mahogany and other tropical timbers?

No. Authoritative studies by bodies such as the World Bank and the London Environmental Economic Centre show that restrictive trade measures do nothing to prevent the problem of deforestation but may encourage it by reducing the economic value of the forest. A single species may be sourced from countries with very diverse environmental records and so it would be very unfair to discriminate on the basis of species.

What about lesser known species?

It can be useful to specify a wider range of timber. The use of lesser known species can assist certain countries, usually in the tropics, with the implementation of their sustainability programmes by taking pressure off those species which have in the past formed the bulk of their business. In seeking to increase the range of species used, you shouldn't compromise on quality or performance. Your choice of species should always be governed by the need to ensure that it is technically suited to the application.

Should I favour timber from certain countries over others?

No. In general it is much better to base purchasing decisions on the environmental performance of individual suppliers. Studying a country's forest policy will greatly assist the development of an effective environmental purchasing policy. This will allow timber buyers in the UK to assess the conditions under which overseas suppliers operate. All the UK's major timber supplying countries are actively implementing national forest management programmes with the aim of achieving sustainable forest management.

Should I request all timber to be independently certified?

Not yet, for the simple reason that there is very little certified timber available. This reflects the limitations of certification schemes rather than the quality of forest management. Therefore, alternative assurances of the well-managed nature of forest sources should be sought through appropriate specification clauses.

What about illegal logging?

The TTF condemns all illegal logging and encourages companies to seek evidence through documentation or, where possible, visits to check that suppliers are trading according to the laws of their country.

How can I help to reduce waste?

A single tree trunk will yield several different grades of timber. Restricting specification only to the highest grade results in only a portion of the tree being used. By seeking to specify all grades of timber, you would be helping to maximise the yield.

How can I specify wood responsibly?

The best way forward is to work closely with reliable suppliers. Suppliers should be able to provide evidence that they are implementing their environmental policy.

They should be able to confirm that all timber has been derived from legal sources and has been managed according to the laws and regulations governing forest management in that country. If a company makes a claim that they derive their timber from a 'sustainable' or 'certified' source they should be able to produce evidence to support their claim. A specification clause can be used as a guide.

What is a specification clause?

A specification clause places a condition on the supplier rather than the sustainability or country of origin of a particular species. The following specification clause may be used as a guide:

1. This organisation supports the development of credible timber certification schemes, which are based on publicly available forestry standards drawn up in a fully participatory, transparent and objective manner and backed by independent auditing. Where possible, this organisation will prefer timber and wood products sourced from forest areas certified under these schemes.
2. Where independently certified timber is not available, this organisation will prefer timber and wood products from suppliers that have adopted a formal Environmental Purchasing Policy for those products and that can provide evidence of commitment to that Policy.

Further details of the Environmental Purchasing Policy promoted by the Forests Forever Campaign can be obtained from the TTF.

This information has been reproduced by kind permission of the Timber Trade Federation.

How to Buy Wood

015 Hardwoods

016

Modern luxury

Walnut ⬂ is as famous for its natural decorative qualities as it is for its fruit. From Queen Anne furniture ⬂ to the interiors of modern luxury cars ⬂, walnut is one of the most desirable veneers ⬂.

This uncompromising range of furniture uses neutral steel and aluminium to contrast and enhance the rich grain and natural colour variation in this type of walnut. In contrast to the highly decorative nature of the wood, the simple, non-decorative structures allow the natural beauty of the coarse texture, cracks and knots of the walnut to be displayed.

The walnut tree also produces tannin as an astringent and as an antidote to some poisons. Procured by distilling the leaves, tannin is often used to soften leather. Walnut kernels are also processed to make oil.

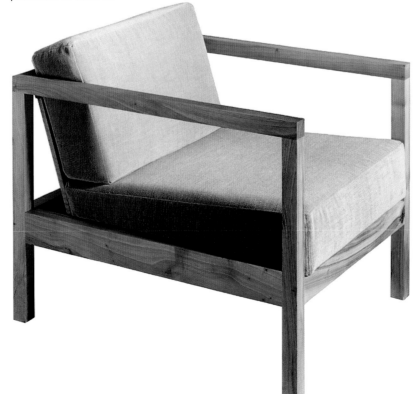

Byron Armchair
Designer: Philipp Mainzer
Client: E15
2000

Dimensions	Byron Armchair: 84 x 68 x 62cm
	Fara Sideboard: 180 x 45 x 67.5cm
Material Properties	Colour can vary
	Straight or wavy grain with a coarse texture
	Excellent steam-bending properties
	Easy to work; Polishes to a high finish
Sources	Europe; Asia Minor; South West Asia
Further Information	www.e15.com
	www.viaduct.com
Typical Uses	Decorative veneers; gun and rifle stocks; shop fittings; furniture; interior joinery; car interiors

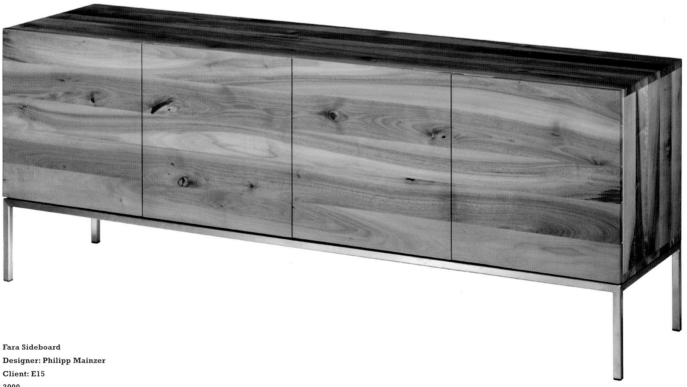

Fara Sideboard
Designer: Philipp Mainzer
Client: E15
2000

018

Permanent shadow

This project exploits the natural ability of wood to change its colouring on exposure to light. This altar furniture was a winning entry in a competition organised by a church that was destroyed in a fire. Originally the altar was to be made in Corian®, but the diocese opted for a natural material instead. Although second choice to begin with, the selection of bleached, white sycamore ↘ became a far more appropriate medium for the project. The wood's milky-white, mottled colour emphasises the importance of the furniture ↘, and contrasts effectively with the darker wood elsewhere inside the church.

The newly renovated church kept the varied shaped arches of the original architecture. When light comes in through the east window, the top of the altar casts an arch-shaped shadow on its own curved front and back legs. The natural light forms a continual shadow on the wood and over time will change the colour of the altar, leaving an inverted shadow stained permanently onto the wood.

(The creamy-white colouring of sycamore often leads to confusion. In the USA for example sycamore is usually referred to as maple ↘.)

Altar Furniture
Designer: Debbie Wythe
Client: Holy Trinity Church,
Beckenham, UK
1997

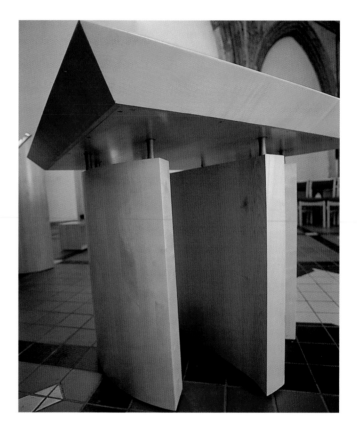

Dimensions	90 x 122 x 122cm
Material Properties	Usually straight-grained; Can be curly or wavy
	Easy to work; Good for turning
	Very low stiffness
	Good steam-bending properties
Sources	Europe; Western Asia
Further Information	www.wythe-uk.com
Typical Uses	Kitchen utensils; butchers' tools and tables; flooring and turnery; violin backs

Fine-tuning

Beech ↘ is one of the most widely-used woods in the UK, from utility furniture ↘ found in school classrooms to domestic kitchens. It is strong, elastic, finishes well and is easily worked.

Inspiration for the Momentos bureau came from the rather strange-looking furniture featured in 'Saint Jerome in his Study', a Renaissance painting by Antonello da Messina. All features deemed superfluous to the function of the bureau have been stripped away. The end of the shutter is linked to a small pull-out extension table giving the bureau a valuable surprise element. When work has finished for the day, everything can be put away, 'out of sight, out of mind'.

This type of beech has a strength comparable to European ash ↘. Its uniform grain and pattern do not contrast with the colour of the wood itself. It also has a uniform density making it relatively easy to work, ie cut, machine, sand or sculpt. These qualities are demonstrated in the design of the Momentos which boasts a finely machined 20mm-deep routed groove that sits a mere 8mm from the circular edge.

Momentos Bureau
Designer: KC Lo
1998

Dimensions	100 x 40 x 100cm
Material Properties	**Close, consistent straight grain**
	Excellent strength
	Good workability
	Can produce an excellent finish
	Excellent steam-bending properties
Sources	**Central Europe and West Asia**
Further Information	**www.mosstimber.co.uk; kc@netmatters.co.uk**
Typical Uses	**Shoe lasts; shoe trees; tool handles; toys; furniture; brush handles; cabinet-making; sports goods; turned products; kitchen utensils; parts for musical instruments**

more: Beech 060, 062, 085, 110; Furniture 016, 018, 021, 024, 026–027, 056, 068, 079, 083, 091, 124, 126; Ash 022, 110

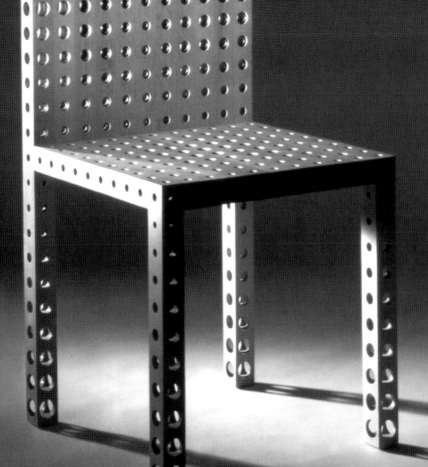

The whole story

Maple ⬎ is an extremely hard, creamy-white wood; an obvious choice for a functional object with so many holes, but these holes are more than decorative. They hide the logic of the structure, a matrix of informed decisions.

'I wanted to make it lighter, both visually and physically, so I drilled some holes in it,' says Gijs Bakker. The size of each hole corresponds to the parts of the chair which require the greatest and the least amount of support. The larger the hole, the less stress is placed on that particular area. Post-drilling, the chair lost almost a third of its original weight.

Dimensions	44 x 43 x 78cm
Material Properties	High resistance to abrasion and wear
	Difficult to work; Good for steam bending
	Reasonable staining and finishing
	Fine and even texture; Medium density
	Usually straight-grained
	Needs to be pre-bored for nailing and screwing
Sources	Europe; USA; Canada
Further Information	www.droogdesign.nl
Typical Uses	Domestic and industrial flooring: squash courts; bowling alleys; roller-skating rinks; shoe lasts; rollers in textile production; furniture and turned ware; maple syrup derivative

Chair with Holes
Designer: Gijs
Bakker
1989

Timber as status

The history of mass production ⬎ is littered with examples of wood being used to decorate everything from television sets and hi-fis to the interiors and exteriors of cars ⬎. These finishes, both genuine and artificial, have long been exploited to enhance product quality in the eyes of the consumer.

Office furniture ⬎ is often used to communicate business confidence, particularly in the USA. There can be few materials that stand for quality, reliability and assurance in the way that wood does. The Shuttle Collection is made from maple ⬎ and cherry which provide the structural integrity and durability necessary for this type of product. This family of contemporary wooden units allows professionals to create flexible workspaces while reinforcing the message of traditional values.

Material Properties	High resistance to abrasion and wear
	Difficult to work; Good for steam bending
	Reasonable staining and finishing
	Fine and even texture; Medium density
	Usually straight-grained
	Needs to be pre-bored for nailing and screwing
Sources	Europe; USA; Canada
Further Information	www.gunlocke.com
Typical Uses	Domestic and industrial flooring; squash courts; bowling alleys; roller-skating rinks; shoe lasts; rollers in textile production; furniture; turned ware; maple syrup derivative

Mosaic Case Goods

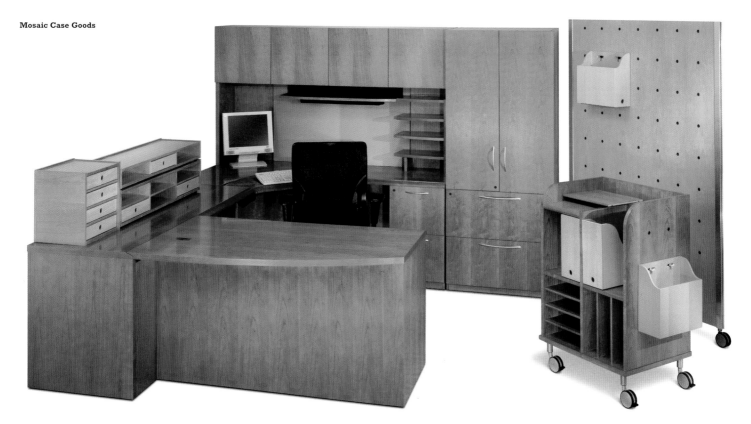

022

Strong and flexible

From transport to weapons of war, ash ↘ is well known for its flexibility ↘ and is, in fact, one of the toughest English timbers around. It is also an excellent shock absorber.

The stools by Hans Sandgren Jakobsen were designed for the Walk the Plank project where 40 designers were each given a plank of wood from which to produce a seating item. 'It was luxury to be able to develop a product without any consideration for commercial interest. It was a playful assignment and a great opportunity to go all the way, to go crazy,' explains Hans.

The Rockable and The Unrockable stools explore new ways for people to sit in a unique and sculptural structure. The Rockable stool is made from 37 staves fixed into a circular foot, at the end of which is a turned knob. The Unrockable follows the same principle, but instead has 35 staves in a rectangular base.

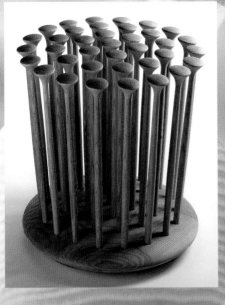

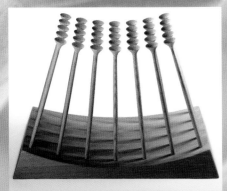

The Rockable and
The Unrockable
Designer: Hans
Sandgren Jakobsen
Manufacturer: HB Trædrejeri
and Lars Verner, 1999

Material Properties	Straight-grained; Coarse texture
	Excellent workability when steamed
	Outstanding toughness; Good flexibility
Sources	America; Canada; Europe; Japan
Further Information	www.trannon.com
	www.hans-sandgren-jakobsen.com
Typical Uses	Railway coach vehicle construction; hockey sticks; snooker cues; cricket stumps; gym equipment; tool handles such as hammers, shovels and axes; oars; early cars; aircraft

more: Ash 019, 022, 110; Flexible 022, 054, 058–059, 108, 115, 118, 123

Fine cabinet wood

**Eighteen Cabinet
Designer and
Maker: John
Makepeace
1996**

'Something that interests me is using materials for their best properties.' John Makepeace ⭷ is one of the foremost designers and makers of wooden furniture ⭷ in the world. He set up the Parnham Trust in 1977, where he teaches wooden-furniture design and continues to inspire and enthuse with his own design ranges. His innovative use of timber in the construction of Hooke Park College ⭷ demonstrates his interest and responsibility towards the use of sustainable materials in architecture.

John's pieces are a celebration of wood in all its functional and aesthetic forms. Each item of furniture may involve the use of several types of timber. The main frame and drawers of the Eighteen Cabinet are made of English cherry ⭷, for its structural qualities and interesting colour. The surface is elm and the drawers slide in and out on runners made of hornbeam, chosen for its ability to take up the friction.

Dimensions	78 x 42 x 140cm
Material Properties	**Good bending and working properties**
	Similar strength to oak
	Excellent for turning
	Generally straight-, fine- and even-textured grain
Sources	**Europe; North Africa; West Asia**
Further Information	**www.johnmakepeace.com**
Typical Uses	**Furniture; tableware; musical instrument parts**

Varied cherry

The Whole Chair by David Landess is made from hundreds of different-sized blocks of cherry wood ↘. It was constructed on its side from a loop form and then turned upright when the final form was completed. 'The Whole Chair was influenced by the idea of using the ubiquitous brick; a very simple and ancient way of producing a structure and perhaps the earliest example we have of mass production ↘ as a tool and process,' says David.

Whole Chair
Designer: David Landess

Material Properties	Good bending and working properties
	Similar strength to oak
	Excellent for turning
	Generally straight-, fine- and even-textured grain
Sources	Europe; North Africa; West Asia
Typical Uses	Furniture; tableware; musical instrument parts

more: Cherry 024; Mass production 021, 047, 086, 116, 123, 128, 131

026
English garden furniture

Tired of the restrictions placed upon the conventional role of industrial design, Anthony, Fiona and Michael produced a series of objects that explore the rituals and eccentricities surrounding the English in their gardens.

'We are interested in designing furniture that actually influences behaviour and we wanted to do a project as an example. We don't promote order and neatness. We are weeds in the world of furniture design,' says Anthony Dunne.

Oak ⬎ was chosen for the rich, historical associations it has with English furniture ⬎ and less for its physical and aesthetic qualities, not being the best wood for outdoor products. Among the range is the Cucumber Sandwich, for growing, straightening and displaying cucumbers. The Cricket Box is a drawer for collecting garden sounds. There are even labels for plant pots that recite poems or recipes to plants called Talking Tabs. These bizarre objects provoke and question relationships, habits and rituals, as well as provide some interesting garden conversation!

Dimensions	Cricket Box: 40 x 15 x 125cm
	Cucumber Sandwich: 100 x 35 x 42cm
Production	Handmade using a range of processes
Material Properties	Coarse texture
	Straight and rich grain
	Good workability and finishing
Further Information	www.michaelanastassiades.com
Typical Uses	Interior furniture; frames; doors; panelling; pews

Weeds, Aliens
and other Stories
Designers: Anthony
Dunne, Fiona Raby,
Michael Anastassiades
1998

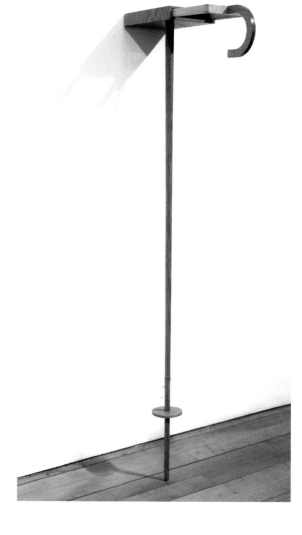

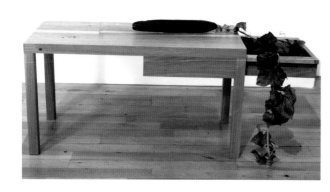

Natural weatherability

Teak ⬂ is often associated with premium garden furniture ⬂ and decking on glamorous yachts. Its distinguishing features of natural weatherability and hardness make it a natural choice for use in the great outdoors. The secret of its good weathering properties lies in the natural oils that clog the pores, eliminating the need for preservatives and making it maintenance-free. It is similar to iroko in this way, which is often used as an alternative.

Unfortunately, buying teak is not so easy on the conscience. Today, most teak comes from colonial plantations in Java, where elephants are still used to move the logs and where a large proportion of the timber is not certified.

Dimensions	**90 x 60 x 75cm**
Material Properties	**Medium density**
	Good for steam bending
	Excellent dimensional stability in a wide range of temperatures
	Good resistance to chemicals
	Moderately easy to work
Sources	**India; South East Asia; The Caribbean; West Africa**
Further Information	**www.tribu.be; www.sydenhams.co.uk**
	www.moderngarden.co.uk
Typical Uses	**Ship-building; cabinet-making; garden furniture; chemical containers; lab benches; decking**

Trolley Table
Designer: Wim Seyers
Client: Tribu
2000

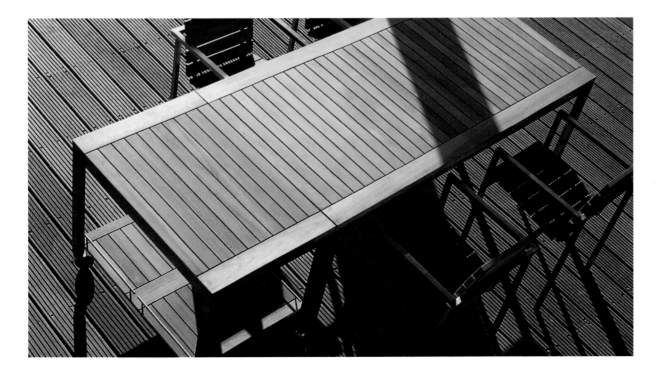

more: Teak 092; Furniture 016, 018–019, 021, 024, 026, 056, 068, 079, 083, 091, 124, 126

028

Take one tree

Oak ↘ is a quintessentially English wood, often referred to in English folklore. One Tree is an ongoing project, initiated by Gary Olson and Peter Toaig in Tasmania, where different uses of this typically English tree continue to be explored and developed.

The One Tree story began in November 1998 when a group of craftspeople, artists, designers and community members came together to develop and demonstrate a more sustainable ↘ and positive future for Tasmania's forests. Their attention focused on one particular 170-year-old oak tree that would otherwise have been made into woodchip. So far the project has raised over AU $10,000, based on the highest bid for each piece of artwork. This money is being used to extend the One Tree example to revaluing whole forests.

By involving people from a range of creative disciplines, the project raises awareness of the rich diversity of uses that the tree offers. From the bark, which has been used to make a dress and tan leather, and its leaves which are used to make paper, to its sawdust, used to smoke ham, and a wood-ash glaze for ceramic pots, nothing in this tree has been overlooked as a potential resource.

Dimensions	**Each 108 x 18 x 6cm**
Material Properties	**Coarse texture**
	Straight and rich grain
	Good workability and finishing
	Good resistance to water
	Excellent for steam bending
Sources	**Europe; Asia Minor; North Africa**
Further Information	**www.onetree.org**
Typical Uses	**Furniture; flooring; boat-building; wine and whiskey barrels; interior furniture; frames; doors; panelling; pews; carving**

One Tree Wall Boxes
Designer: Gill Wilson
2000

more: Oak 026, 103, 110; Sustainable 074, 079, 096

030

Local resources

Drawing on local resources, Dutch design group Droog ⬊ has applied its highly original interpretation of materials and processes to a unique cultural project.

Droog was commissioned to design a family of products based on the themes of restoration, revival and innovation that would reflect and revitalise the culture of the local area of Oranienbaum in East Germany. The abundance of poplar ⬊ made it the most suitable material for this disposable, wooden orange peeler.

Dimensions	20 x 50 x 120mm
Material Properties	Pale colouring
	Tough for its weight
	Good resistance to splintering compared with other softwoods
	Straight- but woolly-grained
	Good workability; Poor for steam bending
Sources	Europe; USA; Canada
Further Information	www.droogdesign.nl; www.gruixe.com
Typical Uses	Matches; interior joinery; toys; break blocks for railway wagons; boxes; crates

Portable Orange Peeler
Designer: Marti Gruixé
Client: Kulturstiftung
DessauWorlitz
1999

ORANIENBAUM
PORTABLE ORANGENSCHÄLER

Wooden textiles

The willow tree yields sleek off-shoots and branches that grow in long uninterrupted lengths, making it an ideal material to weave. The many varieties of user-friendly, long, soft fibres don't splinter easily and so can be used for a range of applications. The true definition of wicker is woven willow, and there are two main types of construction used in the ancient process of basket-making. The first uses a frame as a guide for the basket to be built around. The second is the steak and strand method where the basket is created from a base.

Lee Dalby grows and harvests ↘ his own ingredients for a range of projects, from baskets to architecture. This is a uniquely honest process where the designer is not only working with the processing materials and converting them into objects, but is directly involved in growing and harvesting which he believes is of equal importance for the final products.

'It's important to be involved in the seasonal process. In winter the sap is in the ground and not in the fibres which makes the wood too soft. The branches are bundled to let them dry out ready for working. When they are ready to be woven they are soaked to make them malleable and soft,' says Lee.

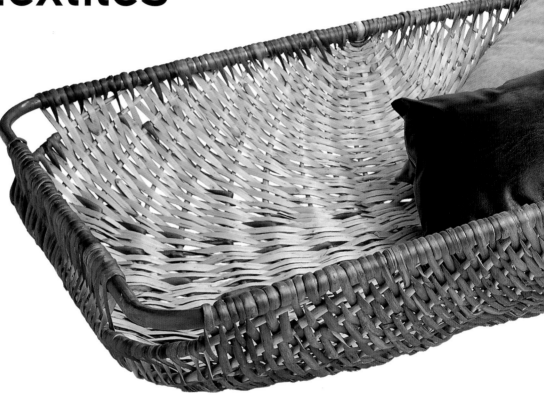

Split Willow-frame Basket
1997

Dimensions	135 x 89 x 25cm
Material Properties	Straight-, fine- and even-grained
	Lightweight; Resilient; Flexible
	Easily worked
	Poor for steam bending
Sources	Europe; Western Asia; North Africa; USA
Further Information	marshchav@hotmail.com
Typical Uses	Cricket bat blades; wickerwork; punnets; clogs; crates; toys; flooring; sliced for moire veneers

4lbs per cubic foot

It is easy to forget that the various species of wood around the world and their physical properties are dictated by diverse climatic conditions. Species like bamboo and balsa thrive in warm climates with plenty of rainfall and good drainage, which enable the trees to grow very quickly. This rapid growth produces lightweight wood ⬊ of such low density that you can push your thumb into it.

Pollinated by tiny seed pods carried and distributed by the wind across the jungle, balsa trees used to be thought of as weeds and still are by some farmers. Within six months of germination the balsa tree can be 10–12 feet and after six years the tree can reach 60 feet and is ready to be cut. If it's harvested ⬊ too late, the outer wood hardens, leaving the inside of the tree to rot.

Today, most commercial-grade balsa comes from Ecuador. Here, balsa is known as boya, meaning buoy. The word balsa derives from the Spanish word for raft, reflecting its excellent floating properties.

Balsawood Surfboard

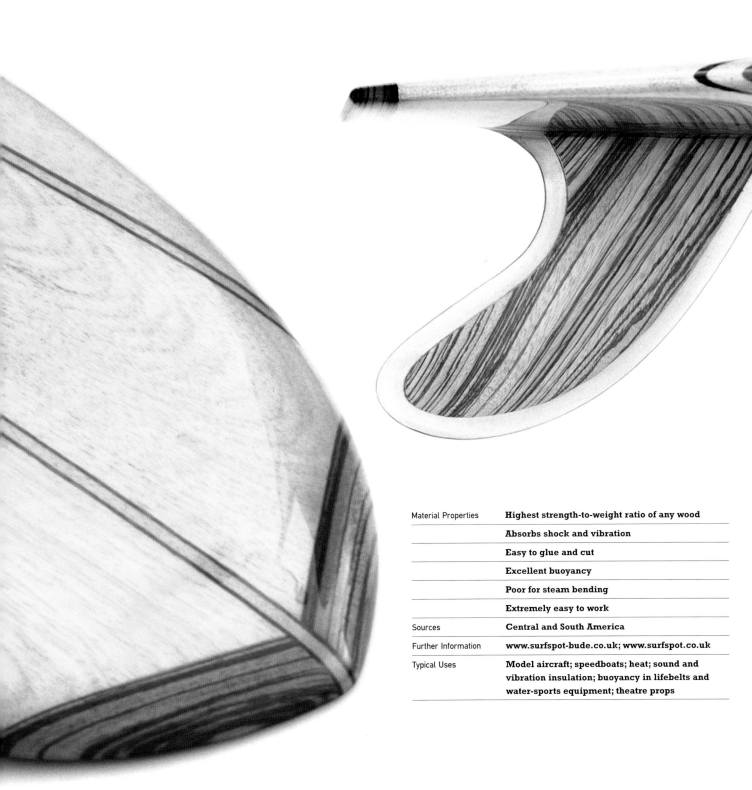

Material Properties	**Highest strength-to-weight ratio of any wood**
	Absorbs shock and vibration
	Easy to glue and cut
	Excellent buoyancy
	Poor for steam bending
	Extremely easy to work
Sources	**Central and South America**
Further Information	**www.surfspot-bude.co.uk; www.surfspot.co.uk**
Typical Uses	**Model aircraft; speedboats; heat; sound and vibration insulation; buoyancy in lifebelts and water-sports equipment; theatre props**

more: Modelling with wood 034, 058; Harvest 031

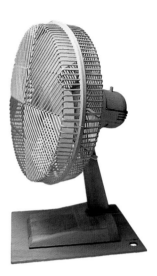

Model classics

This straight-grained, fine and even-textured wood is well known to every design student as one of the most common materials used for model-making. Less well known is Giovanni Sacchi, yet he is generally regarded as one of the masters of wood-modelling ↘.

Over the last 50 years he has worked with some of the most celebrated names in Italian design using predominantly jelutong ↘ and cembra pine for his miniature models. From his small workshop in Milan, Giovanni has crafted over 25,000 wooden models, including cutlery, computers, electric fans, sewing machines, furniture ranges, architectural models and lighting designs.

Anyone familiar with jelutong will know the only problem with working it is in tackling the gooey latex knots in the middle of a plank, which hinders the progress of any slick model. But latex does serve its own purpose of course – feeding the huge market for chewing gum.

Material Properties	Plain, straight, fine and even grain
	Medium density; Low stiffness
	Very easy to work
	Good finishing properties
Sources	Malaysia; Indonesia
Further Information	www.mosstimber.co.uk
Typical Uses	Pattern-making; model-making; drawing boards; wood-carving; wooden clogs; interior joinery; latex for chewing gum

Prototype Models made in Jelutong by Giovanni Sacchi

more: Modelling with wood 032, 058; Jelutong 085

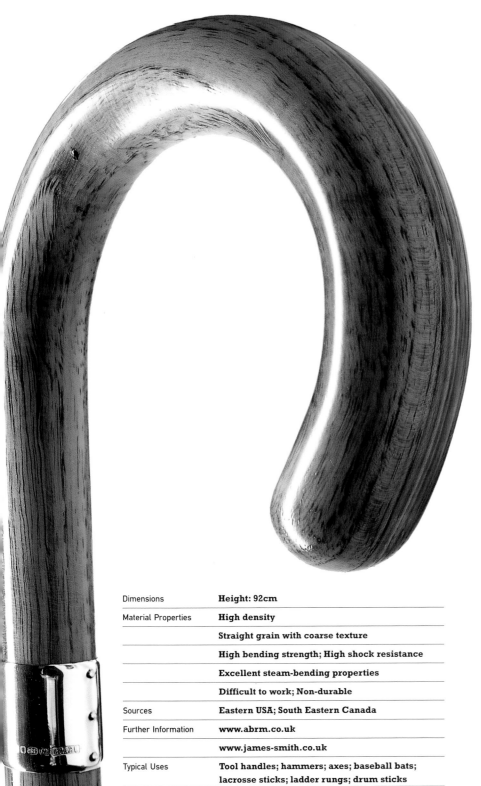

Luxury

Hickory is an exotic wood with a very high density ↘ and an ability to remain sturdy when formed from a thin cross-section. Traditionally used by decadent Victorian gentlemen to show off their status, walking sticks range from plain and simple to incredibly ornate.

These lavish and ostentatious displays of material luxury were the must-haves of their day, well before the branding revolution of the late 20th century. They are admired for the beauty of their surface, colouring and grain, as well as for their perfect harmony of weight, proportion and finish. Satin-smooth and expertly-machined, these simple pieces just yearn to be touched.

Hickory Crook

Dimensions	**Height: 92cm**
Material Properties	**High density**
	Straight grain with coarse texture
	High bending strength; High shock resistance
	Excellent steam-bending properties
	Difficult to work; Non-durable
Sources	**Eastern USA; South Eastern Canada**
Further Information	**www.abrm.co.uk**
	www.james-smith.co.uk
Typical Uses	**Tool handles; hammers; axes; baseball bats; lacrosse sticks; ladder rungs; drum sticks**

more: Dense wood 037, 067, 120

036

Twergi traditions

Alessi's ◢ wooden products represent a return to the wood manufacturing traditions of the Strona Valley in Italy. Alessi has expanded its collection working around the culture and traditions of the 'Twergi' – endearing elf-like creatures who helped and guided the mountain people and worked in wood and metal.

The Twergi Collection of fruit wood ◢ includes pear, apple and maple ◢ woods. Pear has a beautifully smooth and even finish, pale flesh colouring and excellent ability to be turned. It is the perfect timber for small hand-friendly objects.

Material Properties	**Generally only available in small sizes**
	Excellent for turning
	Pale colouring; Good ability to take staining
	Straight grain; Fine, even texture
	Not suitable for steam bending
Sources	**Europe and Western Asia**
Further Information	**www.alessi.com**
Typical Uses	**Drawing and musical instruments; umbrellas; quartered veneers for decorative covering**

**Cheese Grater from the
Twergi Collection
Client: Alessi**

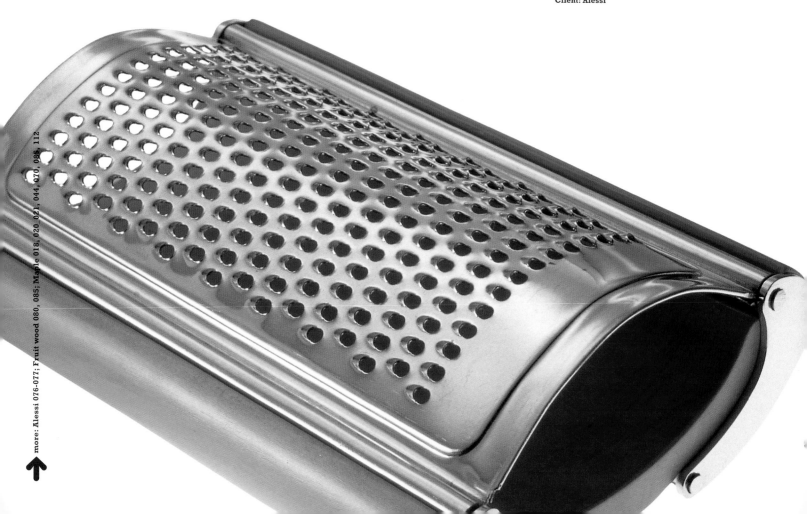

more: Alessi 076-077; Fruit wood 080, 085; Maple 018, 020, 021, 044, 070, 085, 112

Natural lubrication

Lignum vitae ↘ is a super wood; it boasts characteristics closer to other materials than to its own material family. This tough, self-lubricating, exceptionally dense wood ↘ is unique; it is the only wood that sinks in water.

One of its early uses was in mechanical applications. It was used in bearings for propeller shafts in ships which took advantage of its natural lubrication. This quality was also exploited in clocks in the 18th century; lignum vitae was used to replace metal parts that needed lubricating with animal fat, creating clocks of incredible precision.

When first cut, this wood is soft and reasonably easy to work, but on contact with air becomes increasingly hard. More contemporary uses are for croquet mallets and until recently it was often used for hammer heads.

Material Properties	**Self-lubricating; Good for turning**
	Excellent durability
	Very difficult to work
	Poor for steam bending
	High resistance to chemicals
Sources	**Central America; West Indies**
Further Information	**www.croquet.org.uk**
Typical Uses	**Mallet heads; wooden bowls; wheel guides; pestles and mortars; early clock mechanisms; hammer heads; pulley sheaths for ships**

more: Lignum vitae 067; Dense wood 035, 067, 120

Wood for wax

'It's to do with wobbly candles and how you can hold different sizes in what is always the same-diameter hole,' says Anna Frohm. This is just one of the unique features of this new candle-holder that combines so effectively with the reduced Scandinavian ↘ aesthetic and the choice of lime ↘ which reflects the designer's cultural background. The holder uses press buttons to fix the candles to the wood, 'like the positive click you feel when you flick a light switch,' says Anna.

This candle-holder does not use timber in the most radical or inventive way, but it does demonstrate and display the natural surface decoration that comes free with any wood. The monastic design exploits the subtle, pale grain of lime, complemented here with a simple, basic form.

Dimensions	**135 x 85 x 35mm**
Material Properties	**Excellent resistance to splitting**
	Easy to work
	Low stiffness
	Can produce a good finish
	Straight, uniform and fine-textured grain
Sources	**Europe**
Further Information	**Annafrohm@yahoo.com; www.mosstimber.co.uk**
Typical Uses	**Carving; cutting boards in leatherwork and pattern-making; turned products; hat blocks; artificial limbs**

Klick Candle-holder
Designer: Anna Frohm
2002

more: Scandinavia 042, 076, 109; Lime 039, 050

Soft hardwood

Known as the 'carver's wood' or basswood, lime ⬎ is a timber that for thousands of years has provided craftsmen with the perfect physical characteristics for carving. Like balsa wood, lime is one of those timbers which provides the contradicting notion of being a soft hardwood.

With its pale, creamy-yellow-coloured close grain and resistance to splitting, lime is used as the main timber in the playful 'Vine' chair by John Makepeace ⬎. The chair offers a contemporary and relevant example of this wood, which demonstrates its key features. Its good dimensional stability, its ability to be easily worked by hand and its pale colouring, which can easily be stained, are all features that are utilised in the chair. The seat and back provide structural elements, and are made from several planks of wood glued ⬎ together and carved. The decorative qualities of the chair extend the function, by referring to nature and the associations of relaxing in an English garden.

John Makepeace is a designer and maker of furniture based in Dorset, England. His interests, however, are not restricted to this discipline, but extend to education through the Hooke Park College ⬎, which itself is designed using innovative timber-construction techniques.

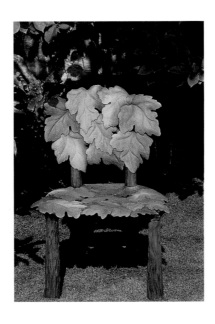

Vine Chair
Designer and Maker:
John Makepeace
1994

Dimensions	55 x 55 x 90cm
Material Properties	**Excellent resistance to splitting**
	Easy to work
	Low stiffness
	Can produce a good finish
	Straight-, uniform- and fine-textured grain
Sources	**Throughout Europe and the UK**
Further Information	**www.johnmakepeace.com**
Typical uses	**Carving; cutting boards for leatherwork and pattern-making; turned products; hat blocks; artificial limbs**

041 Softwoods

High volume

Ikea ↘, one of the largest furniture retailers in the world, has over 140 stores in 22 countries and over 35,000 employees. With these statistics it is fully aware that it must address the environmental impact of its products, 70 per cent of which are made of wood.

Ikea states that, 'Timber used in solid wood products must not be taken from intact natural forests or other forests with a high conservation value, unless the forests have been certified according to the Forest Stewardship Council's (FSC) principles and criteria or equivalent.'

Scots pine ↘ (redwood) is abundant in the northern hemisphere. Consequently, its strength, texture, and the type and size of the knots on its light yellow to reddish brown appearance can vary. Typically, softwoods are fast-growing and cheaper than hardwoods and mostly grown in man-made forests.

Dimensions	**Ivar: 89 x 30 x 179cm; Sten: 89 x 31 x 174cm**
Material Properties	**Easy to work with both hand and machine tools**
	Accepts stain, paint and varnish well
	Low stiffness
	Gluing can be troublesome due to the resin
	Holds nails and screws well
Sources	**North Europe; West Spain; Pyrenees; North Asia**
Further Information	**www.ikea.com**
Typical Uses	**Furniture, joinery and turnery; telegraph poles; railway sleepers and piles; plywood; veneers**

more: Scandinavia 038, 076, 109; Scots Pine 138

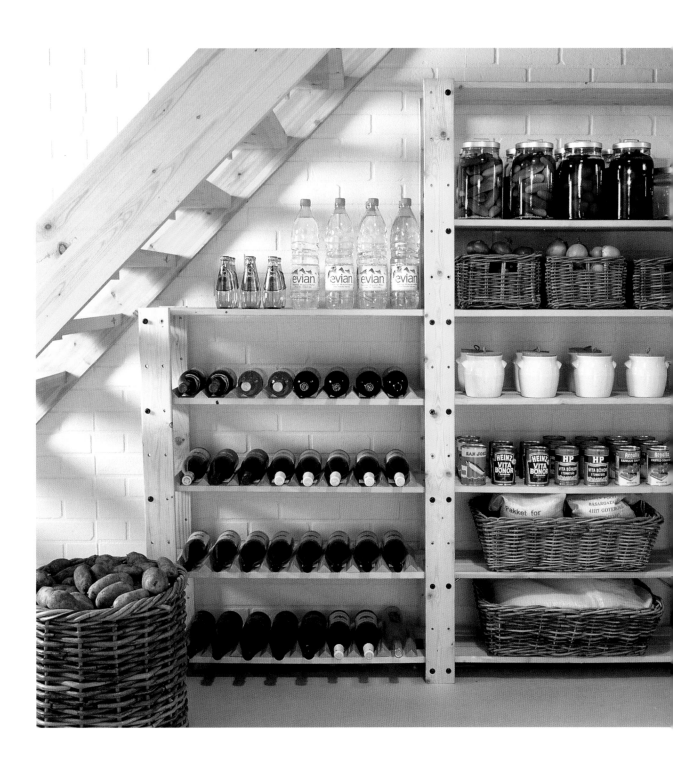

Ivar Basic Unit (left)
Ikea Sweden

Sten Basic Unit (right)
Ikea Sweden

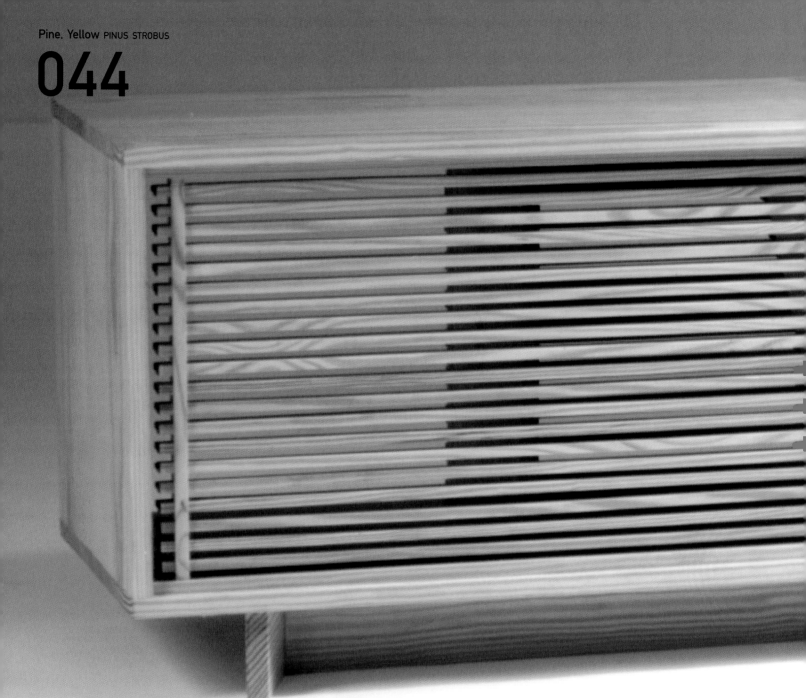

Excellent stability

Dimensions	**150 x 43.6 x 50cm**
Material Properties	**Excellent dimensional stability**
	Soft-, straight- and even-textured grain
	Easy to work
	Allows for good finishing
	Low shrinkage
Sources	**Eastern Canada; USA**
Further Information	**www.woodforgood.com; www.nordictimber.org**
	www.mosstimber.co.uk; b.panayi@virgin.net
Typical Uses	**Pattern-making; doors; drawing boards; light and medium construction; parts for musical instruments; joinery; boat-building; furniture- making**

Xylo Sideboard
Designer: Ben Panayi
Client: Wood for Good
2002

more: Pine 042, 094; Spruce 049; Maple 018, 020–021, 036, 070, 085, 112

Blocks are cut into slats and
treated with wax and stain

Grooves are machined into slats,
ready to accept the writing core

Made from a mixture of graphite
and clay, the cores are placed
into the grooves

A sandwich is made by gluing a
second grooved slat onto the first

The sandwich is machined into
individual pencils, which can be
sanded and painted

DIY production

Some of the most interesting designs are also the most familiar and simple. The first mass-produced ↘ pencils were made in Germany in the 17th century. To mass-produce pencils today, timber is cut into square blocks and then into thin slats, which are waxed and stained. These slats, which are half the width of the final pencil, then have grooves cut into them to hold the graphite. Next, the two slats are glued ↘ together to form a sandwich. This is then machined into pencils, which can finally be painted.

Not only is the straight-grained cedar ↘ the perfect hardness for sharpening, but it's also good for chewing!

Dimensions	78 x 44 x 43cm
Material Properties	Poor for steam bending
	Easy to work
	Aromatic scent
	Low stiffness
	Straight, fine and even grain
Sources	USA; Canada; Uganda; Kenya; Tanzania
Further Information	www.pencils.com; www.pencilpages.com
	www.mosstimber.co.uk
Typical Uses	Cigar boxes; chests and wardrobes; coffins; veneers; shavings; leaves for essential oils

more: Mass production 021, 025, 086, 116, 123, 128, 131; Glue 039, 049, 058, 062, 087, 094, 100; Cedar 050

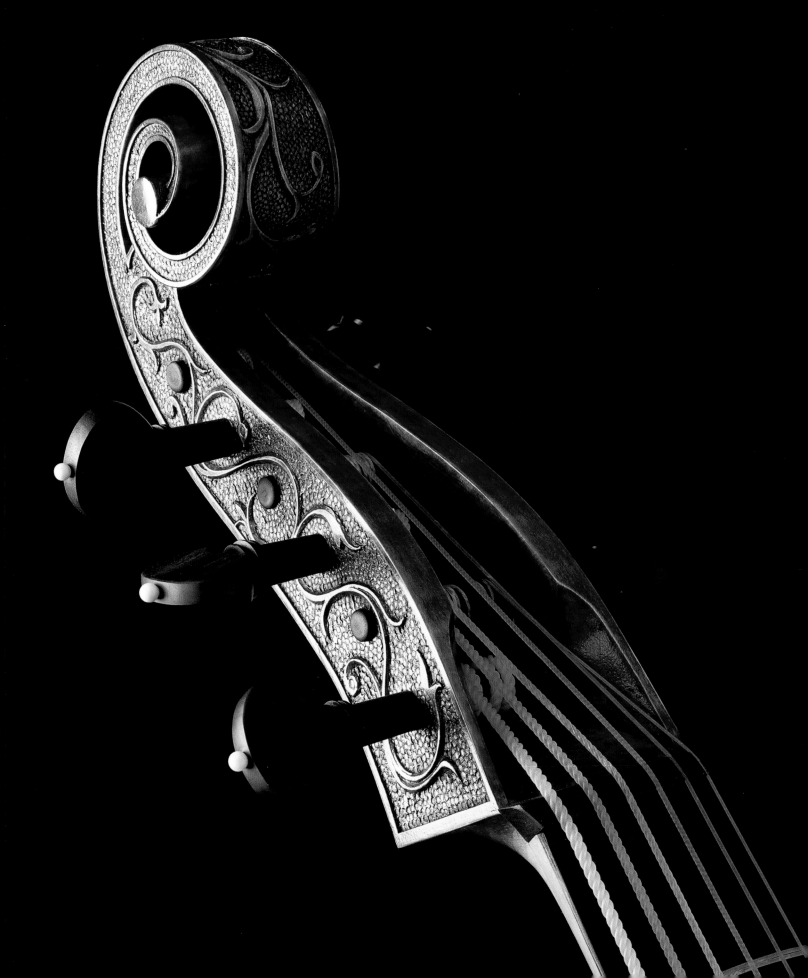

Extraordinary lengths

Jane Julier makes bespoke viols which originated in 17th-century England. Each instrument is commissioned and made to the individual requirements of the musician. The physical craftsmanship reflected by the 200 to 300 hours that goes into making each instrument is stunning. To achieve the perfect balance of acoustics, form and weight the wood is produced to a maximum thickness of 1.6mm with tolerances down to 0.1mm. This is an incredible achievement considering that spruce swells and moves according to the amount of moisture in the air, which Jane overcomes by having a dehumidifier working overtime. And with a shape derived from the golden section, the curves and arches are architectural in their structural logic.

The use of spruce ⬎ for the top and rippled sycamore ⬎ for the back, ribs and neck gives the viols the necessary combination of strength, resonance and weight. Rabbit-skin glue ⬎ is used to assemble all the pieces which means that the whole instrument can be taken apart and serviced when needed. These instruments are some of the most breathtaking examples of control and accuracy in any wooden objects.

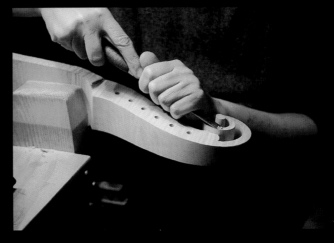

Material Properties	Easy to work
	Pale, straight grain
	Low stiffness
	Medium bending and crushing strength
Sources	UK; Western Russia
Further Information	rossclocks@clara.co.uk
	www.luthierssupplies.co.uk
	www.vdgs.demon.co.uk
Typical Uses	Musical instruments; interior construction; joinery; general building work and carpentry; Christmas trees

Viola da Gamba
Made by Jane Julier 1995

more: Spruce 044; Sycamore 018; Glue 039, 047, 058, 062, 087, 094, 100

Dimensions	Various, depending on shoe size
Material Properties	Easy to work
	Straight grain; Coarse texture
	Strong colour variation
	Poor for steam bending
	Highly distinctive aroma
	Fades to silver-grey after weathering
Sources	Canada; USA; UK; New Zealand
Further Information	www.dunkelman.com; www.mosstimber.co.uk
Typical Uses	Pencils; beehives; wardrobes; inferior grades for construction

The function of smell

It smells! Red cedar ↘ smells good; the kind of smell that evokes memories. Wood has some of the most natural, beautiful and tactile surfaces, but for many species, it's the natural aroma that stays with us. The intense relationship between smell and memory that wood generates elevates it to a higher materials league altogether.

So where better to use a wood with a pleasant and distinctive, strong aromatic smell than in a shoetree? Dunkelman & Sons uses a range of woods for its shoetrees. Starting at the lower end it uses poplar ↘ for its exceptional lightness, and lime ↘ for its clean look, stability and light weight ↘. At the top end is the aromatic and deodorising American red cedar.

Apart from the use of this strong, aromatic wood, the other interesting aspect of these shoetrees is in their production. Starting from the toe and working up, card models are used to slowly build up the form, cutting and layering until a model with approximately 15 to 20 sections is produced to make a perfect fit for a shoe. This solid model can then be used on an assymetrical copy lathe to produce each individual tree. Only one model is needed, as the machine can be adjusted to form each shoe size. These wonderful moisture- and smell-absorbing accessories are hand-finished and sanded.

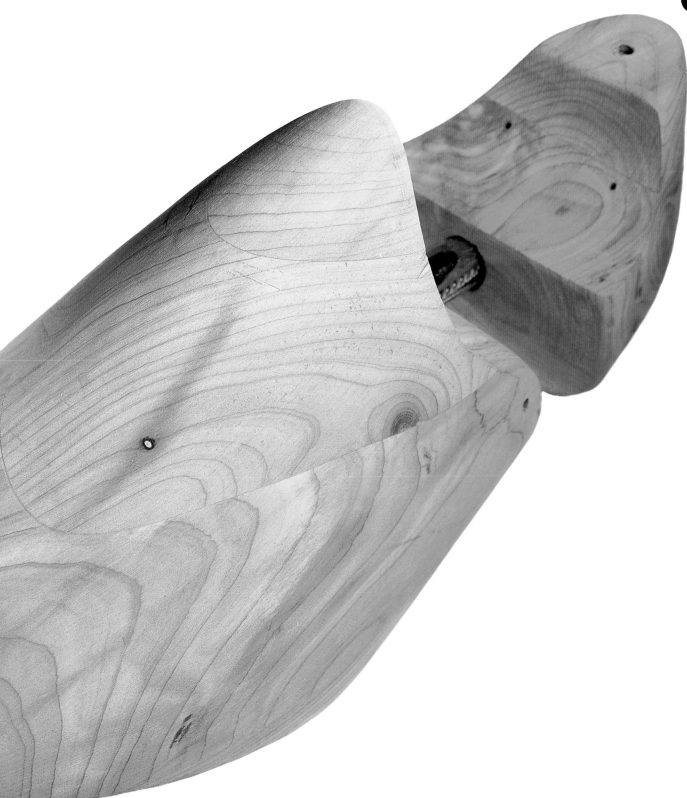

more: Cedar 047; Poplar 030, 087, 128; Lime 038–039; Lightweight 032, 068, 079
↑

053 Flat

054

Three-dimensional sketching

Dimensions	**79 x 76 x 81cm**
Material Properties	**Good dimensional stability**
	Available in a range of thicknesses and finishes
	Easy to work
Sources	**Manufactured in various parts of the world according to the origin of the timber**
Further Information	**www.knoll.com**
	Wood Panel Industries Federation, Grantham, UK Tel: +44 (0) 1476 563707
Typical Uses	**Interior, exterior and marine applications; structural and decorative uses**

Power Play
Designer: Frank Gehry
Manufacturer: Knoll
1989–1992

Countless designers have experimented with bent plywood ↘ to produce furniture, but for shear volume and playfulness Frank Gehry offers some of the best examples and demonstrates the properties of this versatile and flexible ↘ material better than any other.

This project was initiated by Knoll who invited Gehry to design some furniture for them. He rented a workshop near his office and worked through his lunch hours to produce a series of three-dimensional sketch models that explored the possibilities of this flexible material. From these he produced 120 prototypes which were taken one stage further; the final designs comprised six chairs and a table.

To create the twisting, bending, curling forms, each strip is moulded before being assembled; a very labour-intensive process resulting in high unit costs.

One of the main advantages wood has over other materials such as glass, plastic or metal is its immediacy which allows it to be worked and formed with relatively basic tools. This immediacy comes through in much of Gehry's work including the playful experiments which led to the Power Play series.

more: **Plywood 056**, 060, 062–064, 070, 100, 118, 123, 131; **Flexible 022**, 058–059, 108, 115, 118, 123

056

10.2lbs of table

As a technique, laminating ⬊ wood has been known for centuries, but plywood ⬊ is relatively new, first used commercially in the mid-19th century. It is now widespread and often used for its structural rather than its decorative qualities. Foundation 33's Multi-Ply range of rational tables tells a unique story about the production of a piece of furniture ⬊. These designs do not rely on colour and form but instead offer a narrative that demands your attention.

The 10.2lbs table is made from an eight by four feet sheet of 24mm birch ply cut into 72 pieces (four legs, 48 short slats and 20 long slats). Every piece of wood was used, including the dust from the original sheet. The slats were made from the material salvaged from inside the four U-shaped leg sections. They were cut in half and aligned to the outer edge of the table, creating a hole in the centre equal in volume to the four legs. The finished table is 10.2lbs lighter than the original sheet of material.

Dimensions	**115.5 x 115.5 x 36cm**
Production	**CNC-laser cut**
Material Properties	**Good dimensional stability**
	Available in a range of thicknesses
	Good workability and finishing
	Readily accepts wood stain
Sources	**Manufactured in various parts of the world according to the origin of the timber**
Further Information	**www.foundation33.com**
	Wood Panel Industries Federation, Grantham, UK Tel: +44 (0) 1476 563707
Typical Uses	**Furniture; wall panelling; interior accessories**

10.2lbs Multi-Ply Coffee Table
Designers: Daniel Eatock and
Sam Solhaug
Client: Foundation 33
2000

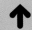

058

Bendy

It is interesting just how desirable a material can become when preceded by the right adjectives. Flexible ⬂ wood is as unlikely a material as transparent aluminium or growable plastic and has been heralded as a great innovation. Like its cousin, bendy MDF, Bendyply™ is a versatile board material which loves to bend and curve without steaming.

Ceiba, also known as fuma, is incredibly fast-growing. It is harvested ⬂ (rather than trees being cut down) and the timber is dried, rotary-cut into veneers ⬂ and glued ⬂ to produce a sandwich board of two materials. This is just one of an increasing number of flexible wooden products both solid and board. Your imagination is the only restriction — go crazy!

Sample of Bendyply™

Dimensions	2.5m x 1.25m grain going in either direction
	Thicknesses: 5mm, 8mm
Material Properties	Low cost
	Lightweight
	Flexible; Easy to form
	Can be laminated to any thickness
Sources	West Africa
Further Information	www.tambourcompany.com
	www.solidwoodflooring.com
	Tel: +44 (0) 1977 600026
Typical Uses	Exhibitions; architectural cladding; drums; counters; shopfitting; furniture; formwork; bars

Pre-cut flexibility

These playful, pre-cut, flexible pieces have
the potential to create relatively smooth,
curved planes with rolling forms. The method
of kerfing ⊠ — cutting slots into wood — is an
old technique for producing flexible shapes
in rigid materials. However, this fairly recent
development of pre-cut MDF boards makes
it much easier to create crooked shapes.

This is a similar material to Bendyply™, but
instead of smooth surfaces both sides, the
flexibility comes from the slots which are cut
at regular intervals into one face of the board.
Most of this material is cut away leaving just
a thin layer which makes the board flexible.
Ideal applications for both of these flexible ⊠
materials is where the structure can be covered
or at least where the edges are not a dominant
feature of the design.

Dimensions	**Thicknesses: 6mm, 9mm**
	244 x 122cm long cut
	122 x 244cm cross cut
Material Properties	**Economical way of creating curves**
	Allows for surfaces to be easily formed
	Smooth surface when curved
	Slots can be pre-ordered to allow for part of the board to have no grooves
Further Information	**www.neatform.com**
Typical Uses	**Furniture; partitions; panelling; shop fittings**

Pre-cut Flexible MDF

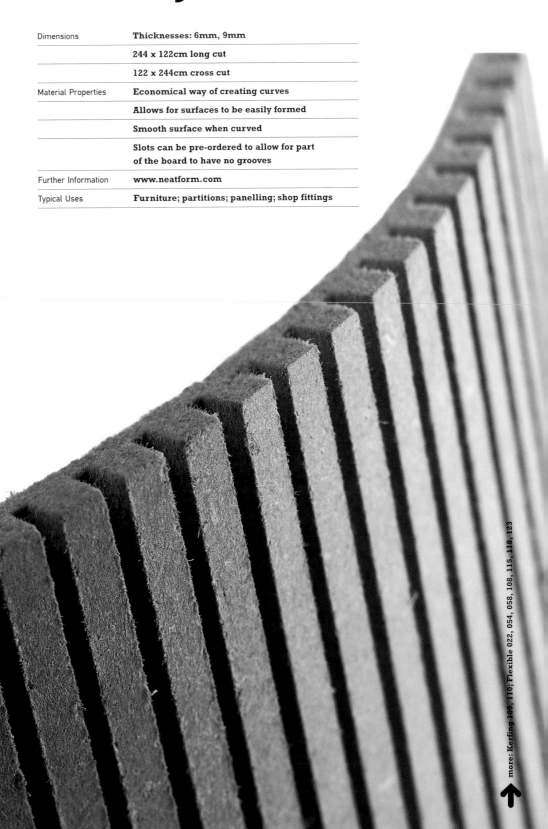

more: Kerfing 108, 110; Flexible 022, 054, 058, 108, 115, 118, 123

060

On the edge

There are plenty of plywood ↘ materials that can be specified. The constructional nature of most of these materials is such that they have a highly distinctive veneer ↘ sandwich edge, which in some cases is used as decoration and in others is concealed. This is a range of ply products where the sandwich principle of construction stays the same but with a more solid edge that looks good.

Multi-ply™ products distinguish themselves by the quality of the core and the face. Multi-ply™ and its sister company Tin Tab™ distribute, fabricate and design a range of innovative ply products. Unlike the more familiar birch ply which is full of plugs because of the knots, these beech ↘ boards use continuous sheets. The logs are steamed and peeled; like a giant toilet roll producing one long sheet. This can then be glued to a solid core without any joints, offering a much cleaner surface. At 2.2mm thick the veneer allows for the face to be serviced more easily than conventional ply.

Dimensions	**Solid oak Tri-ply: 200 x 182cm standard size**
	Harbo solid beech ply: 250 x 125cm
	Thickness: 0.8–5cm
Material Properties	**High quality of face and edge**
	Economical
	Serviceable face
Sources	**Manufactured in various parts of the world according to the country of origin**
Further Information	**www.tintab.com**
Typical Uses	**Desktops; worktops; door seals; stair treads; furniture**

Samples of Solid Oak, Maple and Ash Tri-ply and Harbo Solid Beech Ply

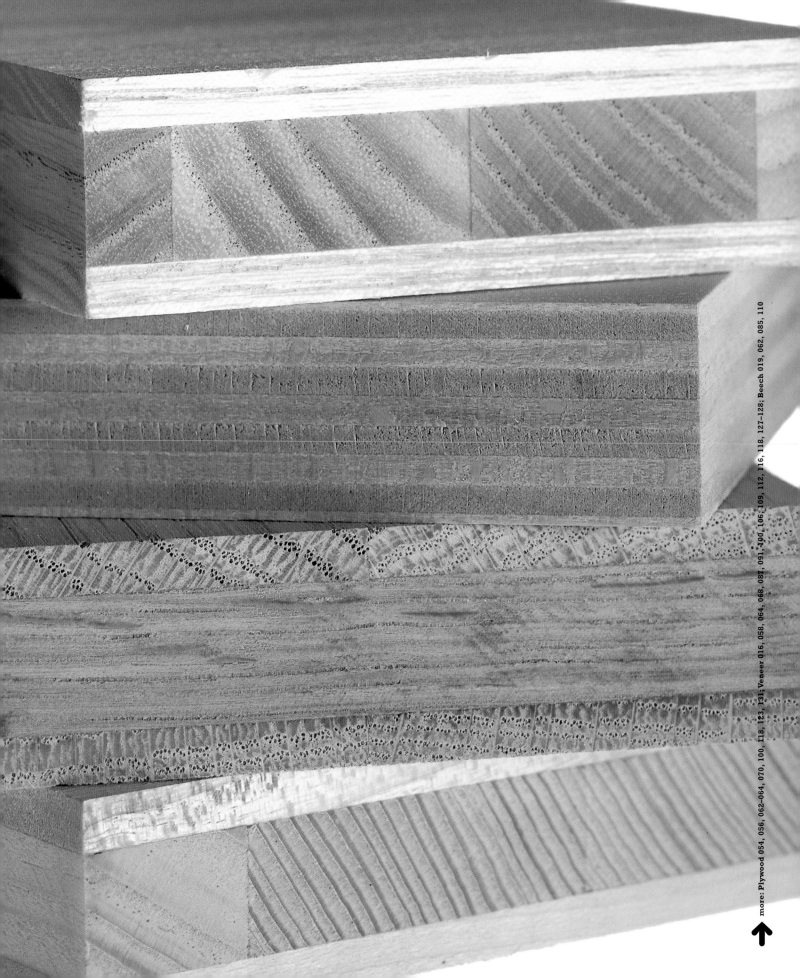

062

Metal replacement

This application relies heavily on the partnership between layers of beech veneers ↘ and phenolic resin. For the last 60 years this compressed, laminated ↘ material has provided us with endless construction possibilities combined with extremely high durability and resilience.

Many types of board material have been developed over the years, providing designers and architects with numerous flat materials. Wood can be re-constituted into countless forms with varying physical properties. Other than timber, the main material in these products is the polymer resin or glue ↘ which holds the particles together. Compressed laminated wood is available in two main varieties: one has the resin impregnated into the wood, the other has the resin coated onto the surface.

Viewed from the side, this compressed, laminated material resembles tightly packed plywood ↘. When sliced across, the grain of the beech is revealed, suggesting the natural timber buried in the resin. Beech is generally used as a base due to its wide availability and straight grain.

Aircraft Propeller Blade, with Compressed Wood and Spruce
Client: MT Propeller

Dimensions	Semi-finished products up to 290 x 290cm
	Finished parts made according to specific requirements
Material Properties	Hard as metal but only a fraction of its weight
	Compression-proof and resistant to wear
	Dimensionally stable
	Absorbs noise; Insulating
	Resistant to water, oil, diluted acids and alkalines
	Stable within a wide temperature range
Further Information	www.permalidehoplast.co.uk
	www.dehonit.com
Typical Uses	Mine sweepers; nuclear shielding; textiles; propeller blades; electrical engineering; the automobile and aeronautical industries; foundries; model construction; sewage works; hammers; skate parks; flooring for London buses

A true fairytale

The development of these flat, wooden panels reads like a fairytale. Once upon a time a marine architect met the girl of his dreams. He asked her father for her hand, who willingly agreed to the marriage, but on one condition: the young lover must turn a failing business, producing winemaking barrels (being replaced by stainless steel), into a profitable company.

The fairytale became a success story. Ravier SA, a French company, used existing production methods to make a non-warping, flat door panel without a frame. Stability comes from cross-bonding three layers of ply: the grain of the two outer panels runs in the same direction, sandwiching a third panel with a perpendicular grain. The panels are vinyl-bonded and set using radio frequency, which produces an invisible joint.

Ravier produces a range of different types of ply ⊾ that can be bonded with clear, coloured or sandblasted acrylic sheets. Panel types can be picked and mixed in a variety of thicknesses, which are ideal for decorating visible edging.

Dimensions	Length and width: made to order
Material Properties	**Non-warping**
	Decorative edges
	Good range of combinations
	Excellent workability
Further Information	**www.taskworthy.co.uk**
	www.ravier.fr
Typical Uses	**Furniture; kitchen units; machined-in hair slides; ends of curtain poles; table legs; doors; cabinets**

**3pli®, Cristal de Ravier®
and Arcance® Samples
Manufactured by Ravier**

more: **Plywood 054, 056, 060, 062, 064, 070, 100, 118, 123, 131**

064

Material as brand

Art directed by the furniture designers Michael Marriott and Simon Maidmont, this is more than a collection of miniaturised adults' furniture. These playful and multi-functional plywood ↘ pieces are simply constructed and can be easily decorated or combined with other materials. Having spotted a niche in the market for children's furniture Oreka has established a brand built around two main themes: children and birch plywood.

Laminating veneers ↘ is a technique which has been practised by craftsmen since ancient times, but the production of plywood is a relatively recent development first used in the mid-19th century. Its main advantage over solid timber lies in the fact that solid timber used in large flat boards is relatively unstable and inclined to distort. Its availability in a range of standard sizes and thicknesses, its ease of use and its excellent stability as large flat panels make it a material with a large range of applications. This, coupled with the range of available grades, makes it the workhorse of many industries.

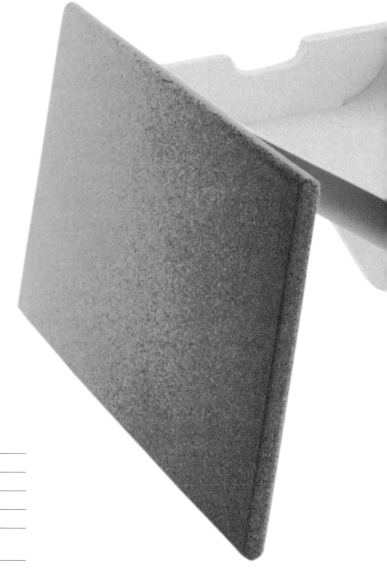

Material Properties	**Excellent dimensional stability**
	Available in a range of sizes and grades
	Easy to work
	Good finishing
	Readily accepts wood stain
Sources	**Manufactured in various parts of the world according to the origin of the timber**
Further Information	**www.orekakids.com**
Typical Uses	**Furniture; wall panelling; interior accessories**

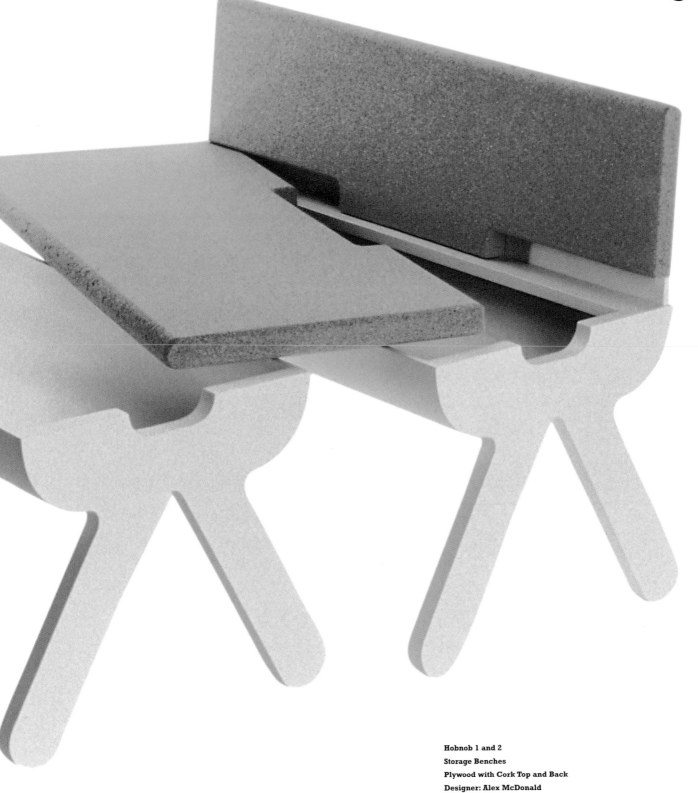

Hobnob 1 and 2
Storage Benches
Plywood with Cork Top and Back
Designer: Alex McDonald
1999

Dense

Compressed Laminated
Hammer with Ash Handle
for Working Hot Sheet Metal
Manufacturer: Thor Hammer

As a product the hammer has to be one of the few where development has been almost totally down to the use of new materials. Its form has remained virtually unchanged since it was realised that a hard object tied to a handle could break things more easily than holding a hard rock in the palm of your hand. Today, the only difference is that the rock is made from an assortment of different materials and instead of being tied, is securely attached to the handle.

There are many different kinds of hammers made from specific materials to suit particular purposes. Traditionally, mallets for beating heated steel panels were made of lignum vitae ⬎. This is now uneconomical and has been replaced by compressed laminated ⬎ wood which has a much higher density ⬎.

Dimensions	265 x 85mm (also available in various sizes)
Material Properties	**Compression-proof and resistant to wear**
	Dimensionally stable
	Noise absorbing
	Insulating
	Resistant to water, oil, diluted acids and alkaline
Further Information	**www.permalidehoplast.co.uk**
	www.dehonit.com
	www.thorhammer.com
Typical Uses	**Applications where there are no metal parts including Royal Navy mine sweepers; nuclear buses**

more: Lignum vitae 037; Laminate 056, 062, 092, 100, 106, 109; Dense wood 035, 037, 120

068

Wooden skin

Veneering ↘ is centuries old. There are countless examples of decorative coverings that maximise the use of rare woods, either over common timber or board products. During the early days of aircraft manufacture thin ply materials were used to reduce weight ↘, including the Mosquito.

The Laleggera Chair (the range includes benches, stools and a table) is an innovative, contemporary example of sheets of wood being used to enhance construction qualities, and combines two totally different materials in a deceptively simple design. These structures use very thin timber and appear to be of a totally wooden construction. However, a closer look reveals that they are made from single sheets of veneer with a plugged hole on the underside to allow for a polyurethane foam injection. The thin veneered sheets are assembled over a solid timber frame before the foam is injected to make the structure rigid.

This highly original wood and foam combo has created a light, strong, ergonomic stacking chair. This is a big selling point for the manufacturer, Alias; in the world of contract furniture ↘ chairs and tables must enable being moved around effortlessly.

Laleggera Chair
Designer: Ricardo Blumer
Client: Alias
1996

Dimensions	53 x 36 x 79cm (Seat height: 46cm)
	Weight: 2,390kg
Material Properties	**Economical use of material**
	Excellent strength-to-weight ratio
Further Information	**www.aliasdesign.it**
Typical Uses	**Aircraft construction; decorative inlays;**
	marquetry; plywood; block board; furniture; doors

070

Tough springs

In the early 1960s 'sidewalk surfing' was featured on the cover of Life magazine and regarded as yet another Californian craze. But this simple plank of wood with four wheels has proved to be much more than just another way of getting around. Skate 'culture' is huge and appeals across the board from the fashionable to the rebellious.

This skateboard would be coveted by every sidewalk surfer. The springy hardness of maple ↘ is put to full use in this product which is formed from maple plywood ↘. The high strength-to-weight ratio and its relatively low cost make is very appealing to skateboarders. Perfect for gliding down handrails, kick flips, lip slides and riding 'vert'.

Skateboard

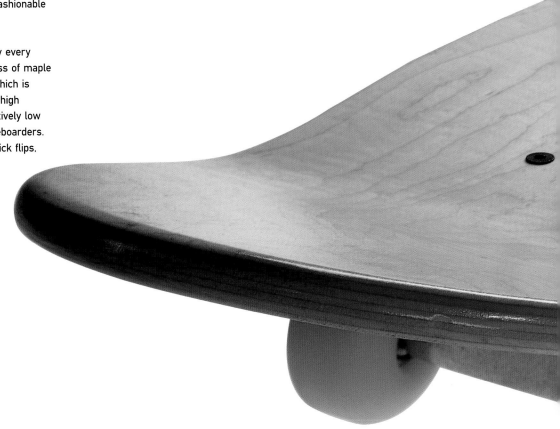

Dimensions	**79 x 19 x 1cm**
Material Properties	**High resistance to abrasion and wear**
	Difficult to work
	Reasonable staining and finishing
	Fine and even texture
	Usually straight-grained
	Medium density
	Good for steam bending
	Needs to be pre-bored for nailing and screwing
Sources	**Europe; USA; Canada**
Further Information	**Skate of Mind, London, UK**
Typical Uses	**Domestic and industrial flooring; squash courts; bowling alleys; roller-skating rinks; shoe lasts; rollers in textile production; furniture and turned ware; maple syrup**

more: Maple 018, 020–021, 036, 044, 085, 112; Plywood 054, 056, 060, 062–064, 100, 118, 123, 131

073 Derivatives

074

Seasonal

Okay, so this material is not really a type of wood and you can't go to a shop or timber yard to buy it — this only contributes to its environmentally-friendly ↘ qualities. Dutch design group Droog ↘, which is well known for pushing the creative boundaries with innovative materials, used it in the Oranienbaum project, among others.

The Gardening Bench is formed using a modern production method combined with a substance nature has provided since the first leaves fell from the first tree. Organic matter is mixed with a resin to create a material that can be pressed and extruded. Almost any kind of organic matter can be used: hay in the summer; leaves in the autumn, and products can also be made and cut to specific lengths. A great combination of abundant organic material and the new application of old technology.

Dimensions	Standard size: 200 x 75 x 78cm, can be cut to desired length
Sources	Manufactured in various parts of the world according to the origin of the timber
Further Information	www.dmd-products.com
	www.droogdesign.nl

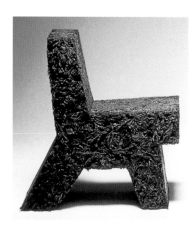

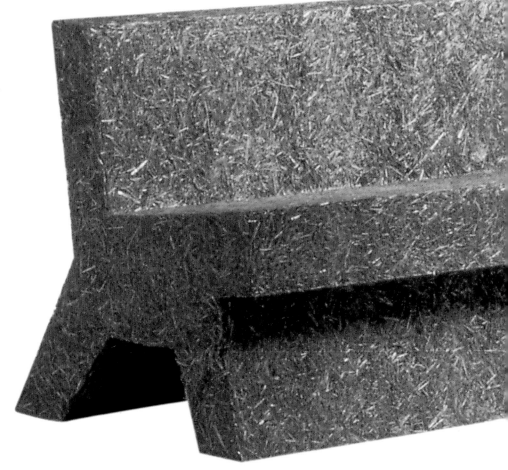

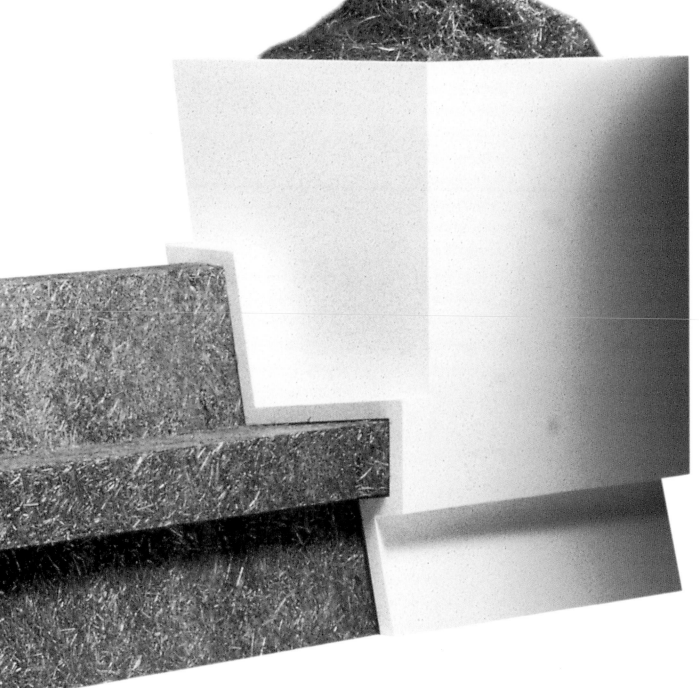

Gardening Bench
Designer: Jurgen Bey
1999

more: Sustainable 028, 079, 096; Droog 030

076

From nature

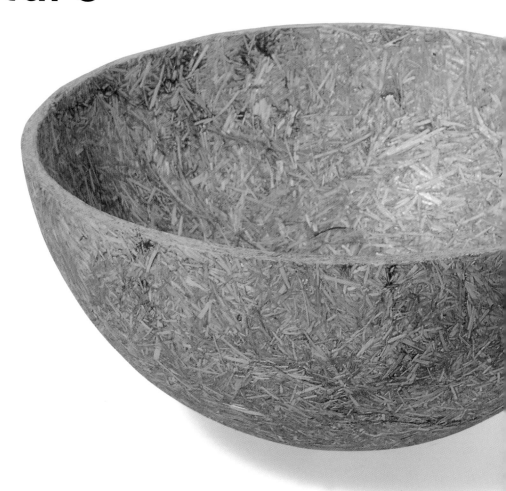

Alessi ⬎ is one of the foremost design-led companies in the world. For many years their product range was made exclusively from stainless steel, but in recent years their stable of materials has been extended to encompass plastic, ceramic, wood and now straw – a by-product of farming.

This new material and manufacturing process resulted from a collaboration with Finnish manufacturer, Strawbius Oy ⬎. The form of the straw bowls has been reduced to a simple hemisphere, allowing the focus of the design to be the rich, intertwined, layered strands of straw. The decorative surface is protected and enhanced with a coating of beeswax, which means that no chemical adhesives are used in production. However, the bowls are not resistant to water and humidity.

The ethnic and traditional craft references contrast significantly with the contemporary colours and surfaces of most of the Alessi range. However, these straw products continue the company's tradition of experimentation – in this case specifically with developments in material and production techniques.

Dimensions	22 x 30cm; 10 x 13.5cm
Production	**Shredded straw, water, potato starch and natural pigments compressed and formed with heat**
Material Properties	**Biodegradable**
	Renewable source
	Low tooling costs
Further Information	**www.alessi.com**
	www.2000.hel.fi/find/strawbius/lassus.html

Straw Bowls
Designer: Kristiina Lassus
Client: Alessi
2000

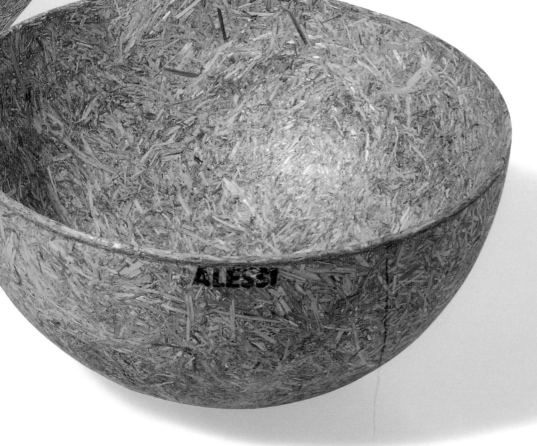

more: Alessi 036; Scandinavia 038, 042, 109

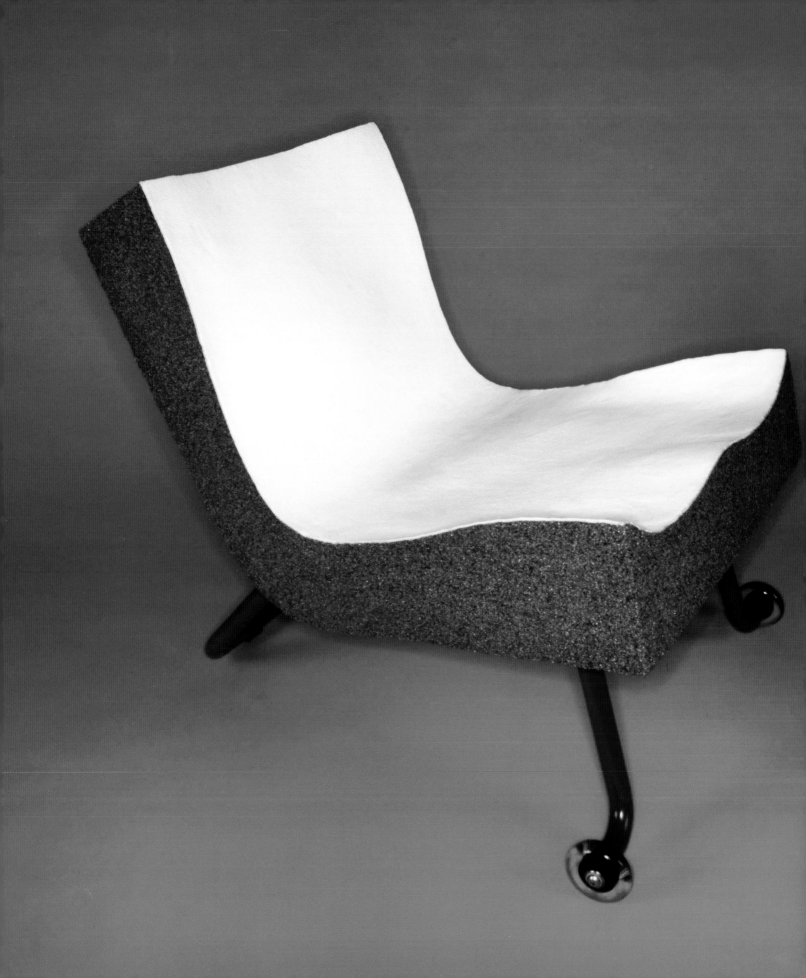

Excellent sealing

With its warm, waxy and spongy feel, cork is another one of nature's wonder materials. It has been harvested and utilised since the time of the ancient Greeks, when its ability to float was exploited by fishermen. Today, about half of the world's cork is produced in Portugal. In the north of the country 30 million cork stoppers are manufactured every day.

It is grown in 14-sided cells in the bark of the tree. These are then impregnated with suberin, a waxy material with sealing properties. The bark is carefully removed in strips, which take nearly six months to dry. These strips are then boiled and left to dry for a further three weeks before being shaped into the end product.

Cork is the only tree whose bark reproduces itself after harvesting, which means it is a totally renewable resource ⬎. Typically, a tree will produce several hundred kilos of cork at each harvesting and will survive for many generations. But with plastic elastomers increasingly taking its place in the wine-bottling industry, new uses need to be discovered for this lightweight ⬎ natural wonder. Contemporary designers like El Ultimo Grito have demonstrated creative applications of cork in modern furniture ⬎ without the usual garden fête associations.

Dimensions	50 x 69 x 61.5cm
Material Properties	Lightweight; Buoyant
	Good elasticity and compression properties
	Impermeable to both liquids and gases
	Good insulator; Fire retardant
	Hardwearing; Renewable source
	Hypoallergenic; Chemically inert
Sources	Portugal; Algeria; Spain; Morocco; France; Italy
Further Information	www.woodfibre.com; www.corqinc.com
	www.granorte.pt/properties.htm
Typical Uses	Footwear; travel cases; handle grips; safety helmets; shuttlecocks; dartboards; bathmats; buoys for fishing nets; wall and floor tiles; vibration dampeners; insulation; furniture

Chair
Designer: El Ultimo Grito

more: Sustainable 028, 074, 096; Lightweight 032, 050, 068; Furniture 016, 018–019, 021, 024, 026–027, 056, 068, 083, 091, 124, 126

080

Not a wood but certainly a derivative, the fruit of the coconut palm is one of the world's most abundant and unique fruits. Like apple and pear, this fruit-bearing tree ↘ is treasured as much, if not more, for its fruit than the wood itself.

The best ideas sometimes arise from restrictive situations. Others work because they take abundant materials and find new applications and contexts for them. The rough hairs that encase the coconut are made into coir – one of the only natural fibres that is rot-resistant – the perfect material for doormats. The fibres can also be formed into insulation boards for use in flooring or ceiling applications, an easy and additive-free production method.

Dimensions	**Individual boards: 1250 x 625mm**
	Thicknesses: 13, 18, 23 and 28mm without compression
Material Properties	**Excellent durability**
	Rot-resistant
	Good thermal and acoustic insulation
	Environmentally friendly
	Almost odourless
Sources	**Tropical regions – Asia, Africa, Central and South America**
Further Information	**www.coirtrade.com; www.coconut.com**
	www.ecoconstruct.com; www.fertilefibre.co.uk
Typical Uses	**Rope; yarns; doormats; rugs; carpets; water filters; ground erosion control; soundproofing; brush bristles; plant mulch**

**Sample of Coconut Fibre Board
Supplied by: Construction
Resources**

 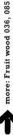

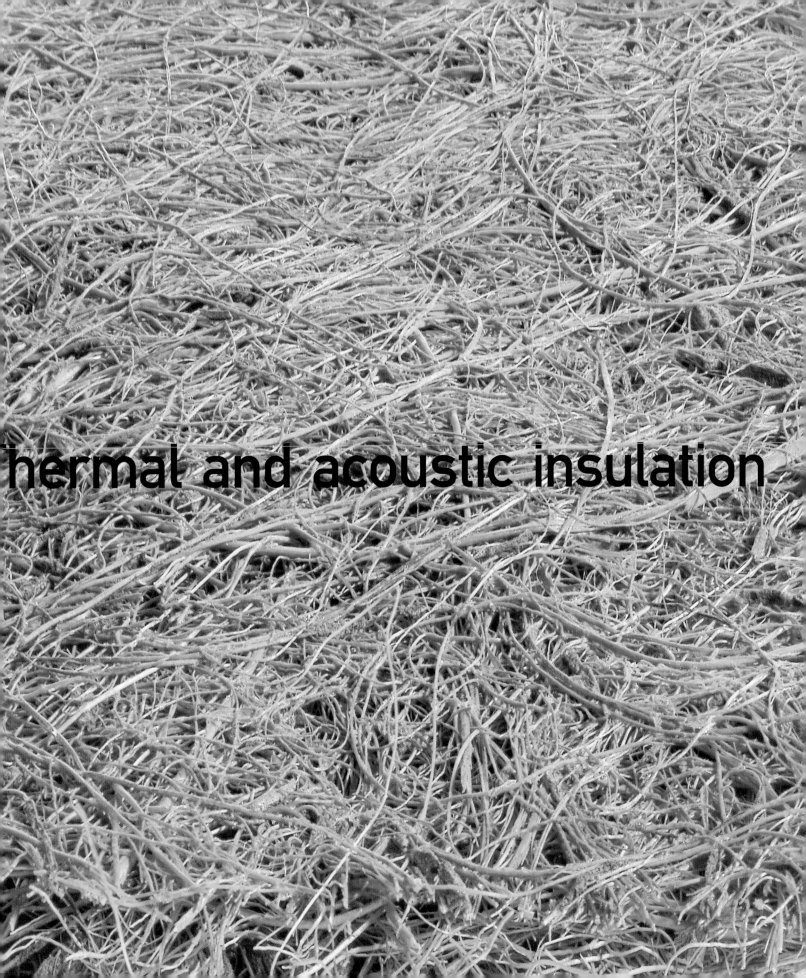

Thermal and acoustic insulation

Chasen Mixing Tool

Dimensions	**115 x 60mm**
Material Properties	**Renewable source**
	Good strength-to-weight ratio
	Low transportation costs
	Structures can be dismantled and recycled
	Low energy processing requirements
	Fast growing; Easy to process
Sources	**Mainly warm or tropical regions**
Further Information	**www.bodley.ox.ac.uk/users/djh/ebs/**
	www.bamboo.org/abs
Typical Uses	**Nutrition and medicine; musical instruments; shelter; flooring; scaffolding; roofing; cellulose; paper; bridges; baskets; furniture; plywood; wind protection in farming**

One metre per day

'On just 500m^2 of land you can harvest a house each year,' says Gunter Pauli.

Bamboo grows more than 30 per cent faster than any other tree on earth. It has provided shelter in tropical and subtropical countries for centuries, not to mention livelihoods for hundreds of generations as the skills of harvesting and construction have been passed down.

Bamboo would be heralded as a wonder material if humans had invented it, as we do with so many artificial materials, such as Teflon® and Velcro®. But in contemporary design and architecture the unique qualities of this amazing natural material are yet to be fully exploited or appreciated. The fact that bamboo is more than two and a half times more cost-efficient for building materials than wood, and more than 50 times cheaper than steel, suggests that it should be considered.

In the right climate bamboo can be grown virtually on your doorstep (low transportation costs). It can be used to construct a building within five years of planting and will continue to grow after it is harvested. With a good strength-to-weight ratio, it can split to form strips for weaving into baskets and furniture ⬂, and with nutritional, medicinal and structural properties, it's the ideal material for survival on a desert island.

more: Furniture 016, 018–019, 021, 024, 026–027, 056, 068, 079, 091, 124, 126

084

Cooked wood

If you want to avoid the nasty fumes from artificially produced briquettes use natural charcoal. In the UK 45,000 tonnes of charcoal are used for barbecuing every year and 96 per cent of it comes from overseas; it is difficult to identify its origin, which could easily be endangered trees. The Traditional Charcoal Company uses coppiced wood from well-managed forests. Cooking the charcoal takes two days and begins with stacking logs in a steel kiln, which looks like a giant cooking pot. As the logs burn, the contents sink and are covered and sealed with sand or earth. After cooking for 16 to 18 hours the charcoal is allowed to cool before being shovelled out, sorted and packed.

Further Information	**The Traditional Charcoal Company, Cheshire, UK** **Tel: +44 (0) 1606 835243**
	British Charcoal and Coppice Association
	Bioregional Development Group, London, UK **Tel: +44 (0) 208 669 0713**

Charcoal

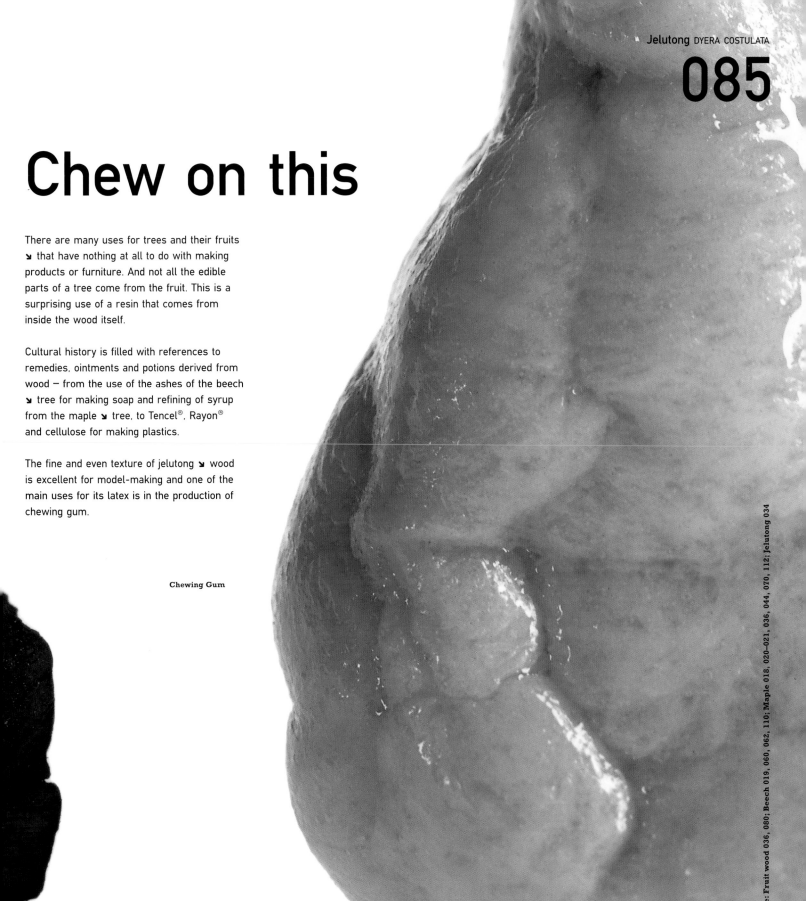

Chew on this

There are many uses for trees and their fruits ⬊ that have nothing at all to do with making products or furniture. And not all the edible parts of a tree come from the fruit. This is a surprising use of a resin that comes from inside the wood itself.

Cultural history is filled with references to remedies, ointments and potions derived from wood – from the use of the ashes of the beech ⬊ tree for making soap and refining of syrup from the maple ⬊ tree, to Tencel®, Rayon® and cellulose for making plastics.

The fine and even texture of jelutong ⬊ wood is excellent for model-making and one of the main uses for its latex is in the production of chewing gum.

Chewing Gum

more: Fruit wood 036, 080; Beech 019, 060, 062, 110; Maple 018, 020–021, 036, 044, 070, 112; Jelutong 034

086

Plastic wood

The future of materials will continue to be heavily influenced by these types of composite, where materials combine to form new ones with multiple personalities. Timbercel® is one of these new materials which will continue to evolve, blurring the boundaries of where one material stops and another begins. It has the efficient mass processability ⬎ of plastic with the workability of wood; a combination of a polymer resin and between 30 and 50 per cent recycled wood flour.

The resulting mix can be best described as plastic wood which can be extruded into specific profiles that can then be screwed, cut, drilled, sawn and sanded like ordinary wood. The properties of this composite offer alternative applications for wood where the wooden component might be exposed to external environments and weathering, because, unlike wood, it does not degrade.

This type of material is not radically new but the improved formulation of Timbercel® allows it to be extruded for applications where long continuous shapes are needed, that can then be worked as if they were wood. By changing the timber and pigments different colours can be created. Although it has not been used for any other moulding technology, future development may lead to a mouldable formulation.

Material Properties	Fire retardant; Durable
	Recyclable
	Good workability
	Good weatherability
Further Information	www.britishvita.com/news/news43.html
Typical Uses	Building and construction applications; window frames; decking

Timbercel

Made-to-order wood grain

Alpi is a world leader in the production of reconstructed wood veneers ↘. The key to understanding the benefits of Alpi's product over traditional wood veneers is the way in which it is produced. With natural wood grains the veneer is created by rotary-peeling thin sheets from a tree. Alpi differs in that, although it uses real wood, the grain pattern is made artificially and therefore virtually any grain, colour and design can be created.

Apart from being able to design your own veneer pattern with Alpi, the key advantage for many industries is its consistency with each leaf, which would not be possible with a natural veneer. Because it uses just two varieties of tree, Italian poplar ↘ and ayous from Cameroon, prices do not suffer from the same fluctuations as wood. Also, there are no knots, splits or other natural imperfections.

The process begins with a two-dimensional image being produced on Eafwood's CAD system, or a natural veneer is scanned. Real wood is then rotary-peeled from a tree, then dyed and glued ↘ under high pressure to form a solid block in a special mould. The new veneers are sliced from the block once it has dried. The end result feels and looks like any other natural veneer and can be handled and joined in just the same way.

Dimensions	Lengths: 220–340cm
	Standard width: 62cm
	Thickness: 0.3–3mm; Lumber thickness: 25–90mm
Material Properties	Stable price; Low waste
	Cost-effective when compared with Burrs and Birds Eye grain patterns
	Harvesting on good forest management
	Can be replicated using trees with high growth rates
	Virtually any natural or artificial pattern can be created
	Can be used in the same way as natural veneers
Sources	Reconstituted from local timber
Further Information	www.eafwood.co.uk; www.alpiwood.com
Typical Uses	General joinery; furniture; flooring; musical instruments; doors; picture frames; desk accessories

Veneer Samples
Manufacturer: Alpi

more: Veneer 016, 058, 060, 064, 068, 091, 100, 106, 109, 112, 116, 118, 127–128; Poplar 030, 050, 128; Glue 039, 047, 049, 058, 062, 094, 100

089 Architecture

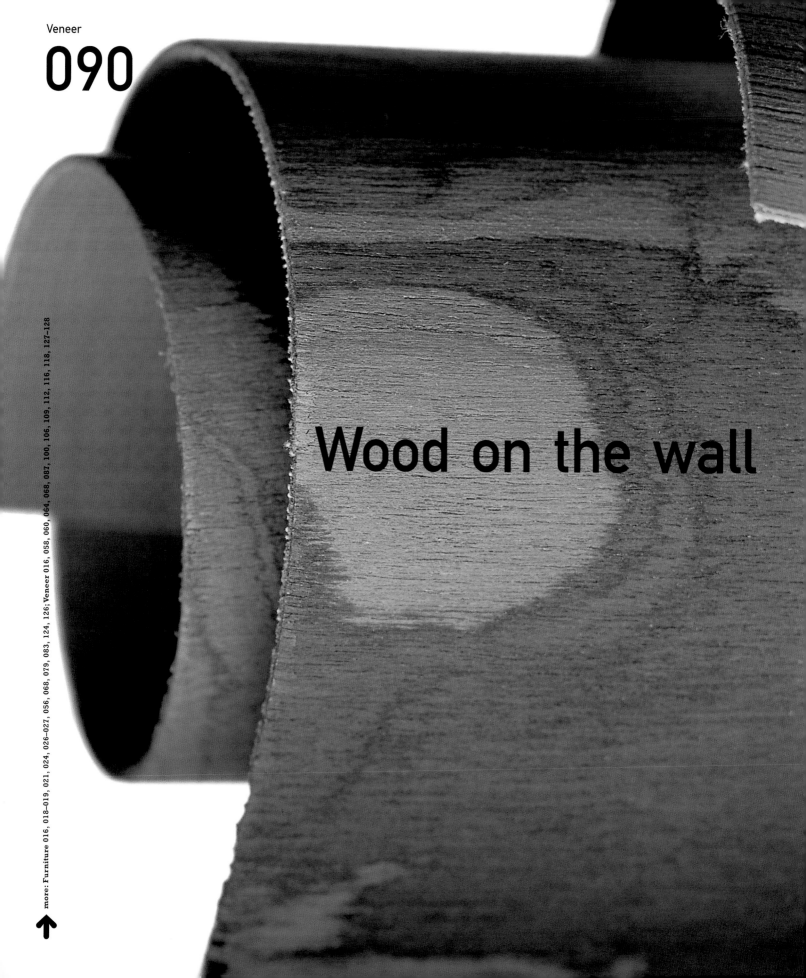

Wood on the wall

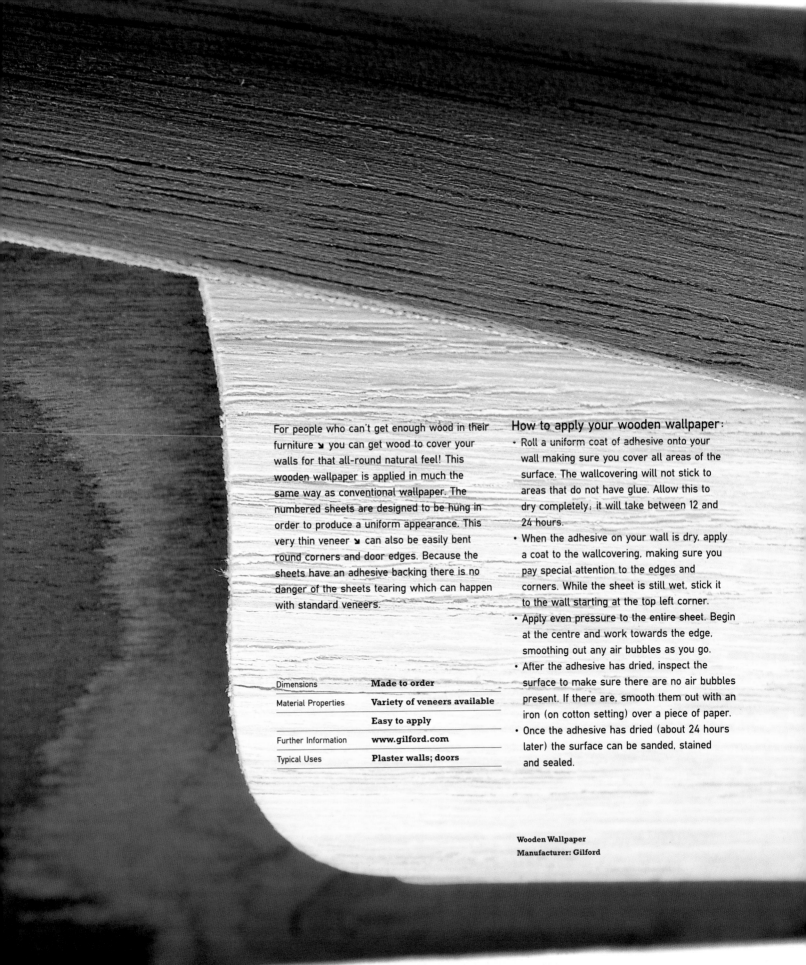

For people who can't get enough wood in their furniture ↘ you can get wood to cover your walls for that all-round natural feel! This wooden wallpaper is applied in much the same way as conventional wallpaper. The numbered sheets are designed to be hung in order to produce a uniform appearance. This very thin veneer ↘ can also be easily bent round corners and door edges. Because the sheets have an adhesive backing there is no danger of the sheets tearing which can happen with standard veneers.

Dimensions	Made to order
Material Properties	Variety of veneers available
	Easy to apply
Further Information	www.gilford.com
Typical Uses	Plaster walls; doors

How to apply your wooden wallpaper:

- Roll a uniform coat of adhesive onto your wall making sure you cover all areas of the surface. The wallcovering will not stick to areas that do not have glue. Allow this to dry completely; it will take between 12 and 24 hours.
- When the adhesive on your wall is dry, apply a coat to the wallcovering, making sure you pay special attention to the edges and corners. While the sheet is still wet, stick it to the wall starting at the top left corner.
- Apply even pressure to the entire sheet. Begin at the centre and work towards the edge, smoothing out any air bubbles as you go.
- After the adhesive has dried, inspect the surface to make sure there are no air bubbles present. If there are, smooth them out with an iron (on cotton setting) over a piece of paper.
- Once the adhesive has dried (about 24 hours later) the surface can be sanded, stained and sealed.

Wooden Wallpaper
Manufacturer: Gilford

092

Low maintenance

Iroko is often used as an alternative to teak ⌄. Its strength, durability and low maintenance requirements made it an ideal material for this remarkable project in the South Pacific. The Jean Marie Tjibaou Cultural Center comprises ten 'houses', all intended as a celebration of Kanak culture. The curved structures, made of wooden joists and ribs, resemble archaic huts, yet each is equipped with all the possibilities offered by modern technology. These ten large spaces, each with a theme of its own, use a rich combination of materials: concrete and coral, aluminium castings and glass panels, tree bark and stainless steel, and laminated ⌄ and natural iroko. All were carefully chosen to reflect and work in harmony with the natural landscape, a relationship typical of Kanak culture.

Jean Marie Tjibaou Cultural
Center, Nouméa, New Caledonia
**Architect: Renzo Piano
Building Workshop**
1993–1998

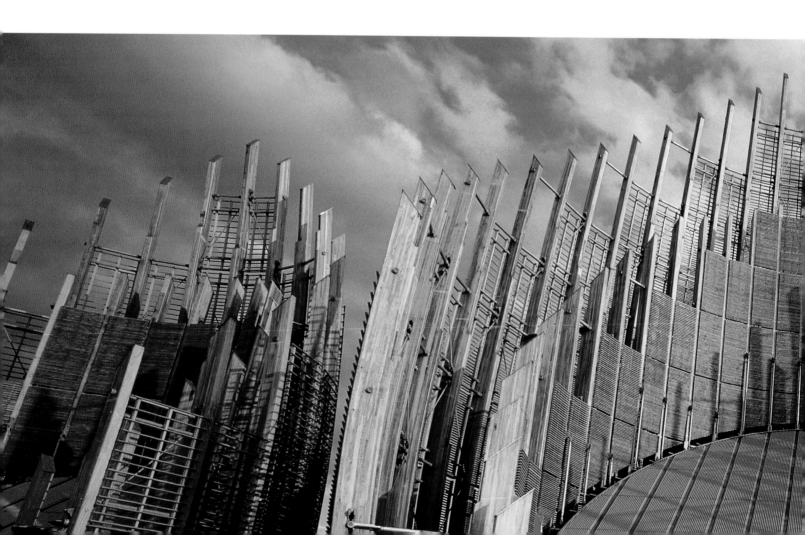

Material Properties	**Medium density**
	Irregular, coarse grain
	Moderate steam-bending properties
	Produces an excellent finish when grain is filled
Sources	**East and West Africa**
Further Information	**www.rpwf.org**
	www.2000.hel.fi/find/strawbius/lassus.html
Typical Uses	**Alternative to teak; boat-building applications; outdoor furniture; bench tops; drainage boards; interior and exterior joinery**

more: Teak 027, 092; Laminate 056, 062, 067, 100, 106, 109

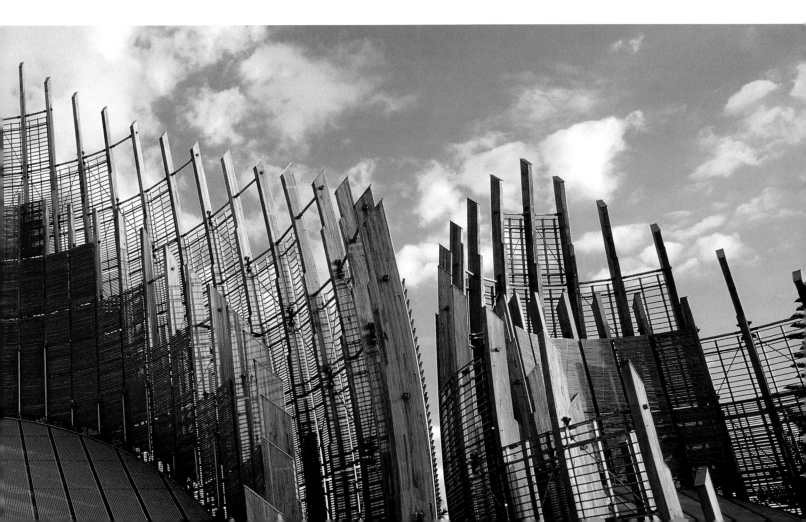

Shredded wood

There are certain advantages to taking a log apart and putting it back together in a different way. Paralam is an engineered construction material made from strands of timber usually six to eight inches long, which are reconstituted and glued together to form building units. During the re-forming process the weaker aspects are removed, leaving a stronger natural material with the same workability as conventional timber.

The process uses much more of the log than could be used by just sawing the tree. The strongest timber comes from the outside of the tree closest to the bark. The inner wood is young and soft. To use this part for conventional sawn timber would be impractical, as the tree would need to be cut into thin, semi-circular planks to isolate this particular wood. That's where Paralam comes in as a way of using this valuable resource.

To make Paralam, a log, typically Douglas fir or pine ⬂, is sliced into veneers which are chopped into fine fibres and mixed with glues ⬂ and resins. The mixture is then heated using microwave technology, which produces a large, solid block that can be cut down into more manageable planks. This process produces a valuable construction material that makes highly efficient use of the original logs.

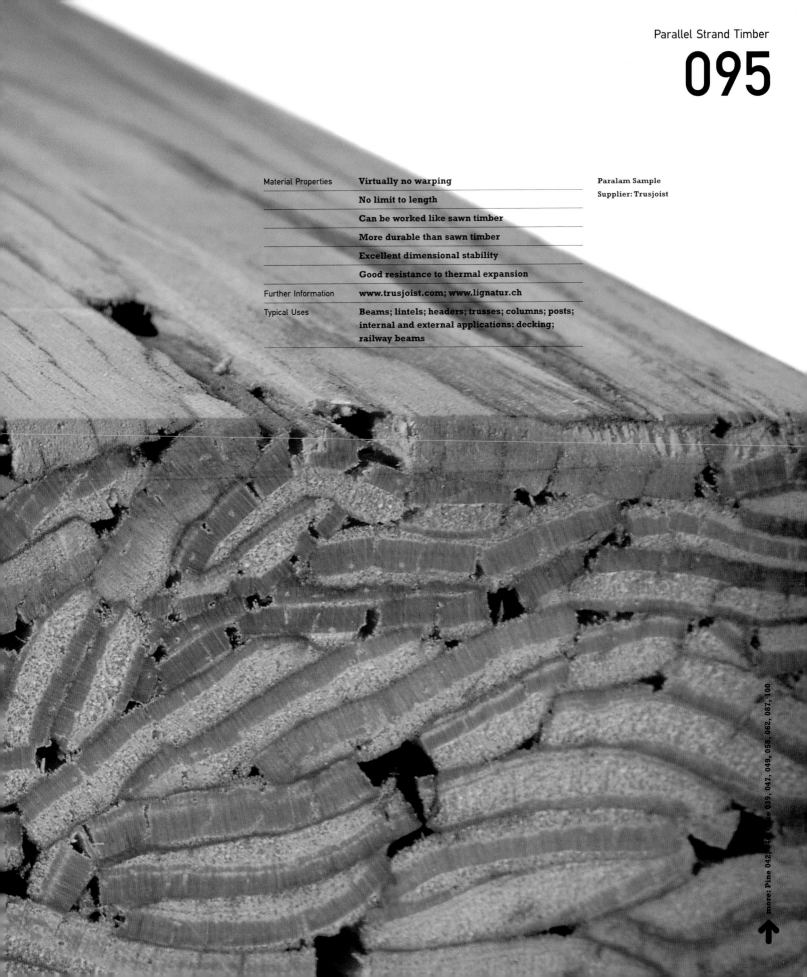

Material Properties	**Virtually no warping**
	No limit to length
	Can be worked like sawn timber
	More durable than sawn timber
	Excellent dimensional stability
	Good resistance to thermal expansion
Further Information	**www.trusjoist.com; www.lignatur.ch**
Typical Uses	**Beams; lintels; headers; trusses; columns; posts; internal and external applications: decking; railway beams**

Paralam Sample
Supplier: Trusjoist

more: Pine 042, 47; Wine 039, 047, 049, 058, 062, 087, 100

A house in three days

Construction Resources promotes the use of ecological building products. The emphasis is on renewing and recycling natural materials which require minimum energy to process.

The Steko Block is a versatile pre-assembled building block that can be joined to others by slotting them together without the need for additional fixings. Cavities in the blocks allow for cables and plumbing which can then be filled with cellulose insulation.

But the real beauty of these Swiss-developed building units is that they use precisely machined off-cuts of materials from the manufacture of other products that are made from fast-growing renewable sources ◞. As well as allowing for faster timber construction than site-specific timber-frame methods, the no-glue principle means that once the building is constructed, it can be easily altered and adapted.

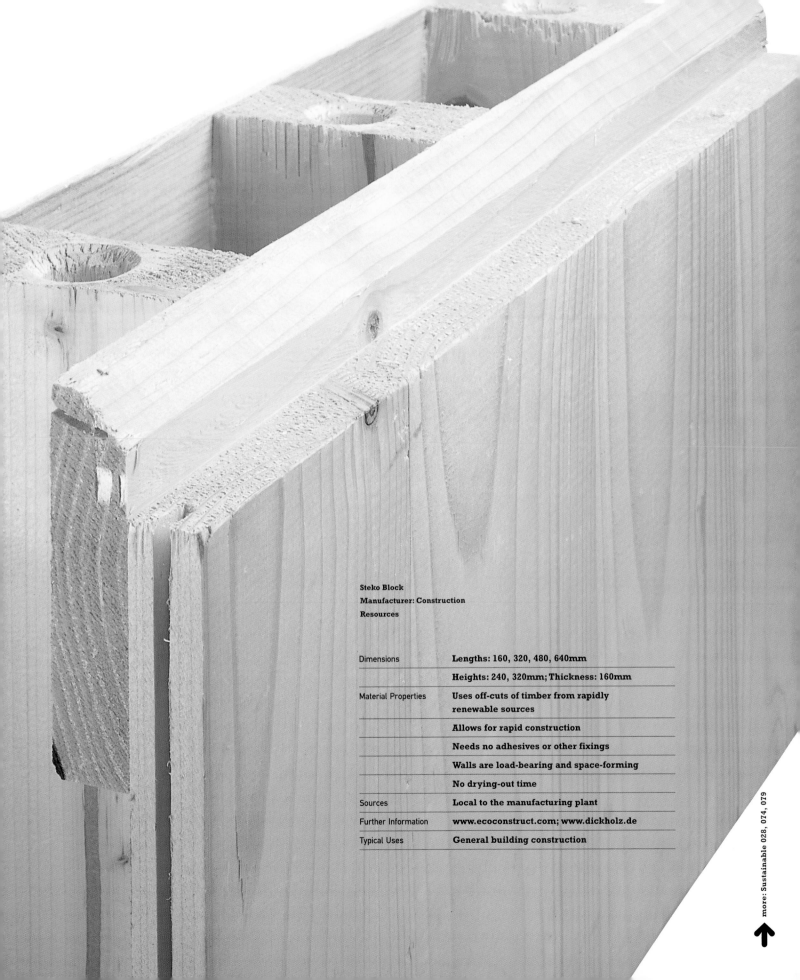

Steko Block
Manufacturer: Construction
Resources

Dimensions	**Lengths: 160, 320, 480, 640mm**
	Heights: 240, 320mm; Thickness: 160mm
Material Properties	**Uses off-cuts of timber from rapidly renewable sources**
	Allows for rapid construction
	Needs no adhesives or other fixings
	Walls are load-bearing and space-forming
	No drying-out time
Sources	**Local to the manufacturing plant**
Further Information	**www.ecoconstruct.com; www.dickholz.de**
Typical Uses	**General building construction**

more: Sustainable 028, 074, 079

098

Local waste resource

A managed forest is a valuable resource which has to be maintained in order for plants to grow healthily. Thinnings are a by-product of forest management and in most cases have no commercial value. Hooke Park ⬎ forms part of the Parnham Trust in Dorset, founded in 1977 by John Makepeace ⬎ as an educational charity. The college uses this otherwise wasted material in a new form of building technology ⬎.

Roundwood timber has long been used for construction but the Hooke Park buildings do not use thick sections of timber. Instead, this unique project demonstrates and promotes how it is possible to use roundwood thinnings from renewable local timber effectively, safely and be environmentally friendly all at the same time.

Material Properties	Uses a collection of different timbers
	Uses local materials
	Makes use of timber which would normally go to waste
Further Information	www.abk.co.uk
	www.johnmakepeace.com

Hooke Park College
Architects: Ahrends, Burton and Koralek
Client: The Parnham Trust
1983–1990

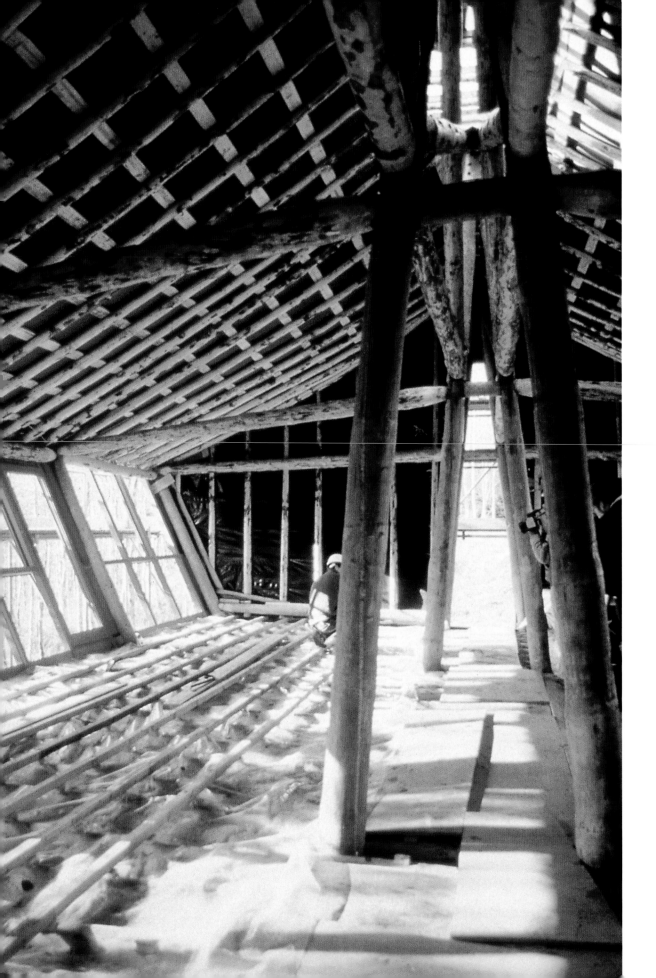

Gluing ⬎ timber together to increase strength is nothing new. In the 1950s the commercial availability of a product called Glulam – an abbreviation of glued and laminated ⬎ – gave architects and designers the freedom to experiment with structural timber in a way that had not been possible before.

By gluing together timbers of different thicknesses (from two layers upwards) the flexibility of sawn wood is reduced and its movement is restricted. This provides a strong and stable structure, which can be made up to any size, the main restriction being dictated by transportation rather than production.

Glulam differs from board materials like plywood ⬎ by using solid wood rather than veneers ⬎. The timber is laminated horizontally and can be glued to produce any curved or straight form without compromising on structural integrity. The construction uses woods of similar strengths and weight. In the UK the main woods used are European white and red woods and larch.

Re-assembled

Glulam Building

Material Properties	**Good dimensional stability**
	Good strength-to-weight ratio
	Economical: lower weight of Glulam cuts costs on foundations, transport and erection
	Environmentally friendly
	Chemical resistance
Further Information	**www.glulam.co.uk**
	www.cwc.ca; www.lilleheden.dk
Typical Uses	**Columns; beams; girders; trusses in interior and exterior applications; salt barns; swimming pools; motorway bridges**

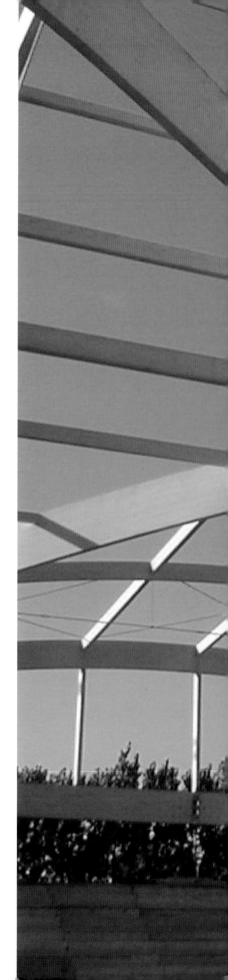

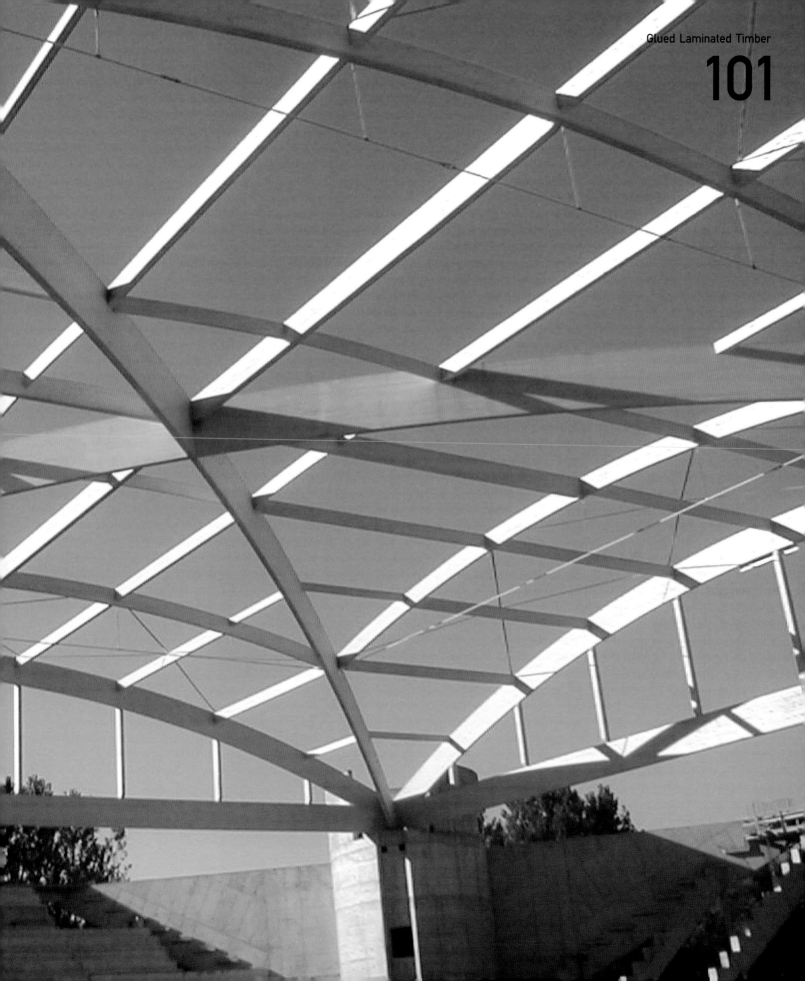

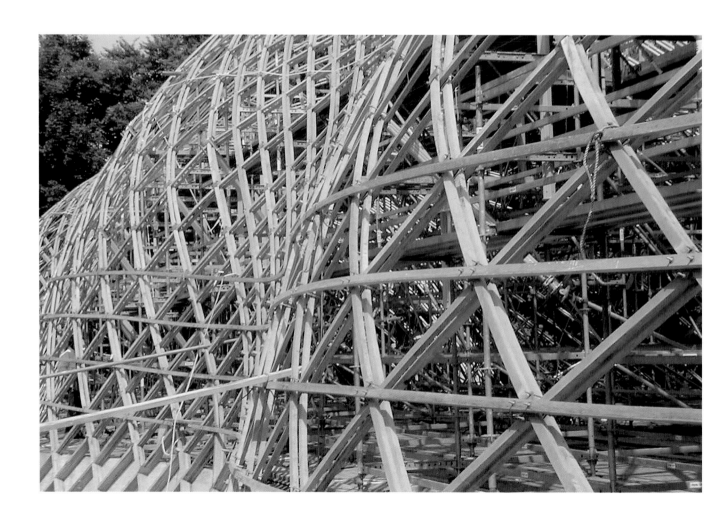

Biodegradable architecture

There are very few true timber gridshell buildings in existence and the Downland Gridshell workshop is the only one of its kind in the UK. Timber gridshells are rare, mainly because effective strategies for counteracting natural forces have yet to be developed, although they date back to Victorian times when Lamella structures were commonly used to form vaults and domes.

This large structure at Weald and Downland is a mesh of relatively thin, local, untreated oak ↘ filaments; another intelligent example of how existing materials have been used creatively. The structure is totally biodegradable ↘ and will last for approximately 100 years.

Steve Johnson explains: 'A shell is a natural, extremely strong structure. A gridshell is essentially a shell with holes, but with its structure concentrated into strips. Timber gridshells have two lives. In their built incarnations, they are formful, resilient, strong objects. In their genesis stages they are perhaps more mysterious as, while being made up of stiff, woven or overlapped linear elements, they behave more like stiff rubber than loose cloth. The particular properties of timber allow it to be deformed into a shape, and then locked.'

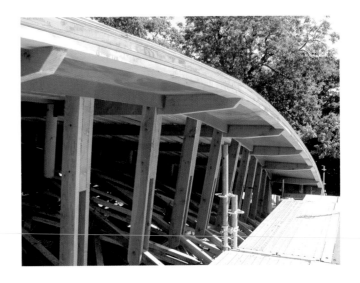

**Weald and Downland
Gridshell Workshop
Architect: Edward Cullinan
Architects
2000–2002**

Material Properties	**Strong structure**
	Uses local materials
	Easy to construct
	Economic use of timber
	Biodegradable
	Fire resistant
	Resistant to fungal attack
Further Information	**www.wealddown.co.uk**
	www.edwardcullinanarchitects.com
Typical Uses	**Fuselages for aircraft; shelters/trellises which eventually biodegrade leaving the plants to retain the original structure**

more: Oak 026, 028, 110; Biodegradable 124

105 Production

Inventive re-using and recycling was the norm in 1940s Britain. Timber chips were put to good use in the form of chipboard which was applied on a large scale for the first time. This cheap, versatile material was later used within a whole range of products, from car ⬆ interiors and exteriors, to radios and hi-fis, usually as a hidden flat panel covered with a more decorative veneer ⬆ or laminate ⬆. For this 'natural' television, moulded chipboard forms an interesting decorative surface rather than being hidden.

Natural electronics

Material Properties	Relatively low tooling costs
	Economical use of timber
	High moisture absorption
Typical Uses	Similar applications that require moulding; industrial packaging

Jim Nature Television
Designer: Philippe Stark
Manufacturer: Thompson
Consumer Electronics for
SABA, France
1993

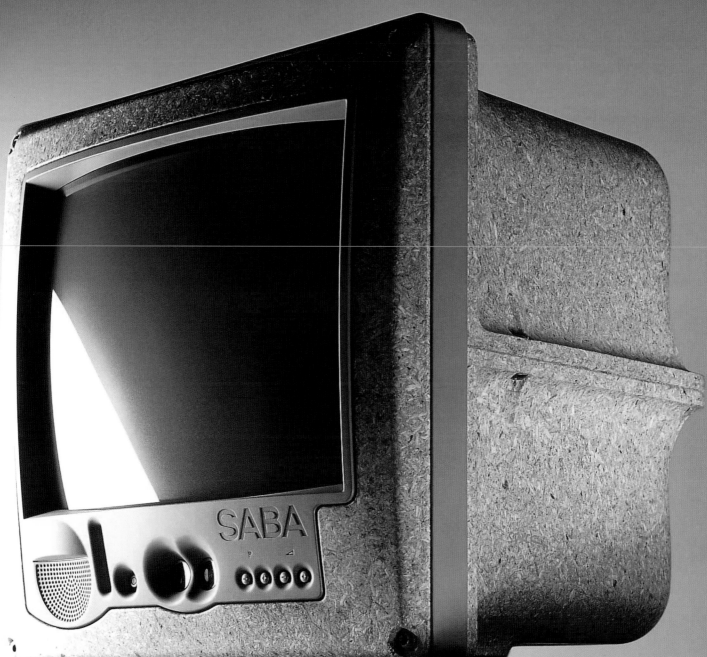

Chemical-free

The amount of twisting and bending that these woods can take before snapping defies belief. This chemical-free production method, which can transform most temperate hardwoods into Bendywood™ ↘ begins with a good quality straight-grained timber. This is steamed to plasticise the cell walls as with conventional steam bending ↘. The now soft timber is compressed along its length with a 60-tonne hydraulic ram which causes the cell walls to compress concertina-style — it is this new structure that gives the wood its flexibility. Flexywood™ ↘, also produced by Mallinson, is permanently flexible ↘ and will not set to shape, making it an ideal timber for edging and lippings.

more: Bendywood™ 110; Steam bending 109–110; Flexywood™ 110; Flexible 022, 054, 058–059, 115, 118, 123

Dimensions	**Available in a range of sizes**
Material Properties	**Flexible at room temperature**
	Available in a range of temperate hardwood timbers
	Can be worked as normal timber
	Allows for easy prototyping
	Not suitable for softwoods
Further Information	**www.bendywood.com; www.compwood.com**
Typical Uses	**Handrails; sports equipment; shopfittings; cabinet-making; signmaking; walking sticks; door handles; curtain rails; furniture**

Sample of Bendywood™

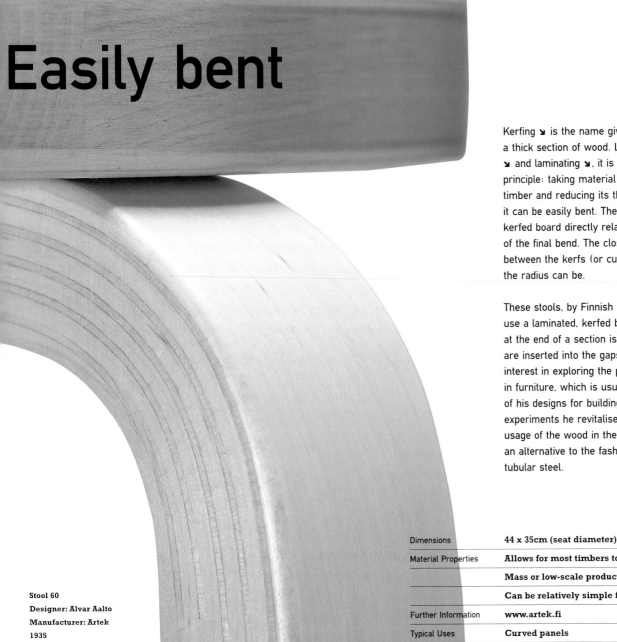

Easily bent

Kerfing ⬊ is the name given to dry-bending a thick section of wood. Like steam bending ⬊ and laminating ⬊, it is based on a very simple principle: taking material away from a piece of timber and reducing its thickness means that it can be easily bent. The width of cuts on a kerfed board directly relates to the tightness of the final bend. The closer the spacing between the kerfs (or cuts), the tighter the radius can be.

These stools, by Finnish ⬊ designer Alvar Aalto, use a laminated, kerfed bend where the grain at the end of a section is kerfed and veneers ⬊ are inserted into the gaps. They illustrate Aalto's interest in exploring the possibilities of wood in furniture, which is usually a direct result of his designs for buildings. Through these experiments he revitalised the language and usage of the wood in the 1930s and developed an alternative to the fashionable Bauhaus tubular steel.

Stool 60
Designer: Alvar Aalto
Manufacturer: Artek
1935

Dimensions	44 x 35cm (seat diameter)
Material Properties	Allows for most timbers to be curved
	Mass or low-scale production
	Can be relatively simple for mock-ups
Further Information	www.artek.fi
Typical Uses	Curved panels

more: Kerfing 059, 110; Steam bending 108, 110; Laminate 056, 062, 067, 092, 100, 106; Scandinavia 038, 042, 076; Veneer 016, 058, 060, 064, 068, 087, 091, 100, 106, 112, 116, 118, 127–128

Relaxed fibres

Depending on the thickness of the wood and the radius to which it is being bent, it can bend without any treatment. Until the invention of Bendywood™ ⬎ and Flexywood™ ⬎, the only way of bending solid timber was by kerfing ⬎ or steam bending ⬎. Applying steam to a piece of wood relaxes the fibres, which allows it to be bent easily round a given form, a widely applied process that was developed by Michael Thonet in the 19th century.

Successful steam bending is partly dependent on choosing the right timber. The selected wood must be free of knots and shakes, and have a straight grain. Ash ⬎, beech ⬎, birch, elm, hickory, oak ⬎, walnut ⬎ and yew can all be steam bent.

This chair was designed by Marc Newson for the House of Fiction Exhibition. The soft form results from steam bending each piece of beech individually according to the radius required.

Steam-bent Chair
Designer: Marc Newson
Client: House of Fiction
Exhibition
1988

Dimensions	75 x 75 x 100cm
Material Properties	Allows for bending into tight curves
	Suitable for mass or small-scale production
	A range of woods can be used
Further Information	www.marc-newson.com
	www.cappellini.com

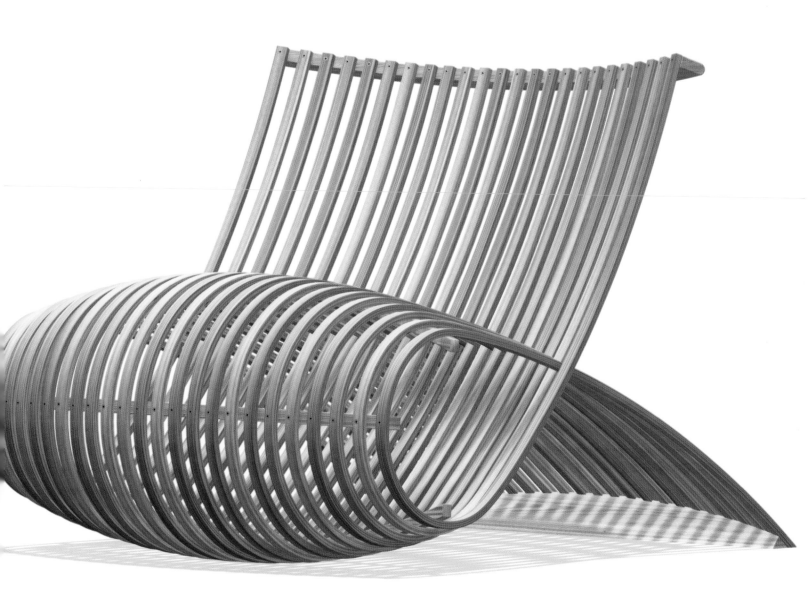

Decadent maturity

Wood is a status symbol for many people. It signifies maturity, confidence and reliability, and refers to the traditional values of the past. Combined with the decadence of leather, the polished veneer of a car ⬎ interior is seductive, lending luxury and quality to the Jaguar brand.

Jaguar uses two kinds of veneer ⬎ in its car interiors: walnut ⬎ bur for the top of the range models and bird's eye maple ⬎ for its executive cars. These robust veneers have to withstand a much greater range of temperatures than would normally be found in fixed interior or exterior environments. The combination of heat and pressure in the forming process makes this possible and a high-tech polyester wax-free coating lends toughness and assurance that these symbols of success will fulfil their long-term warranties.

Jaguar's veneer manufacturing centre is the largest consumer of walnut bur in the UK. It uses an Italian technology ⬎ to form veneers into compound curves and, depending on the part, up to nine separate veneers are glued together and pressed to their maximum without splitting.

Material Properties	Durable
	Decorative potential
	Efficient use of wood
	Low labour costs
	Good accuracy of dimensions
	Environmentally stable
Further Information	www.jaguar.com
Typical Uses	Canteen trays; embossed patterns for surface decoration; furniture inlays; interior mouldings

Jaguar X Type

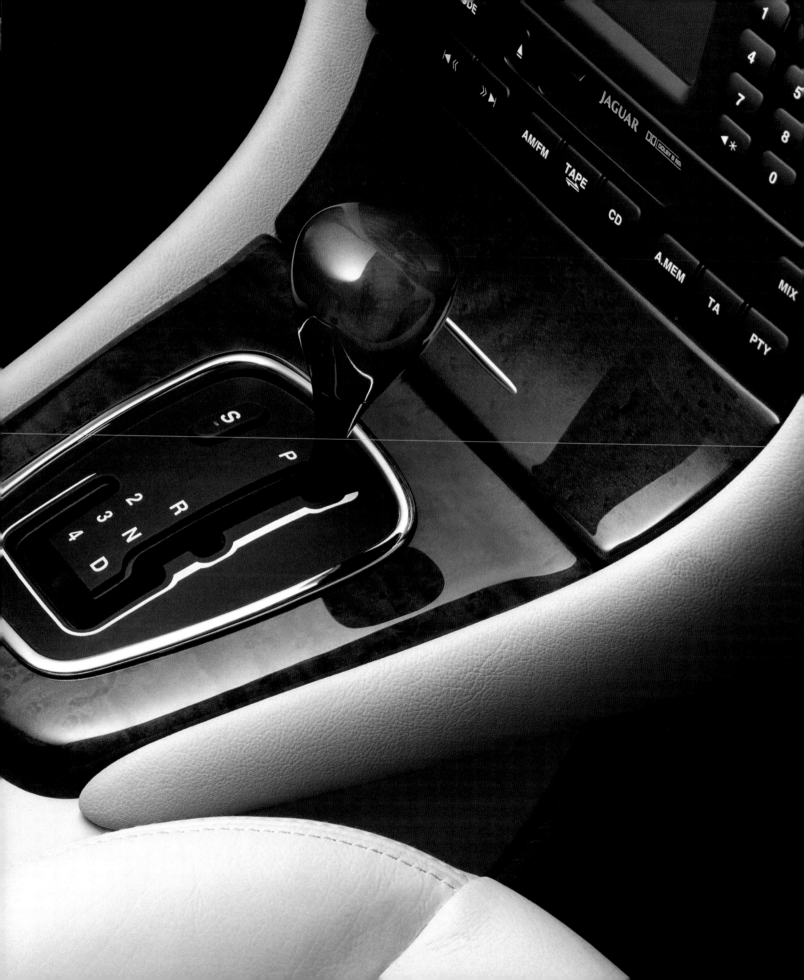

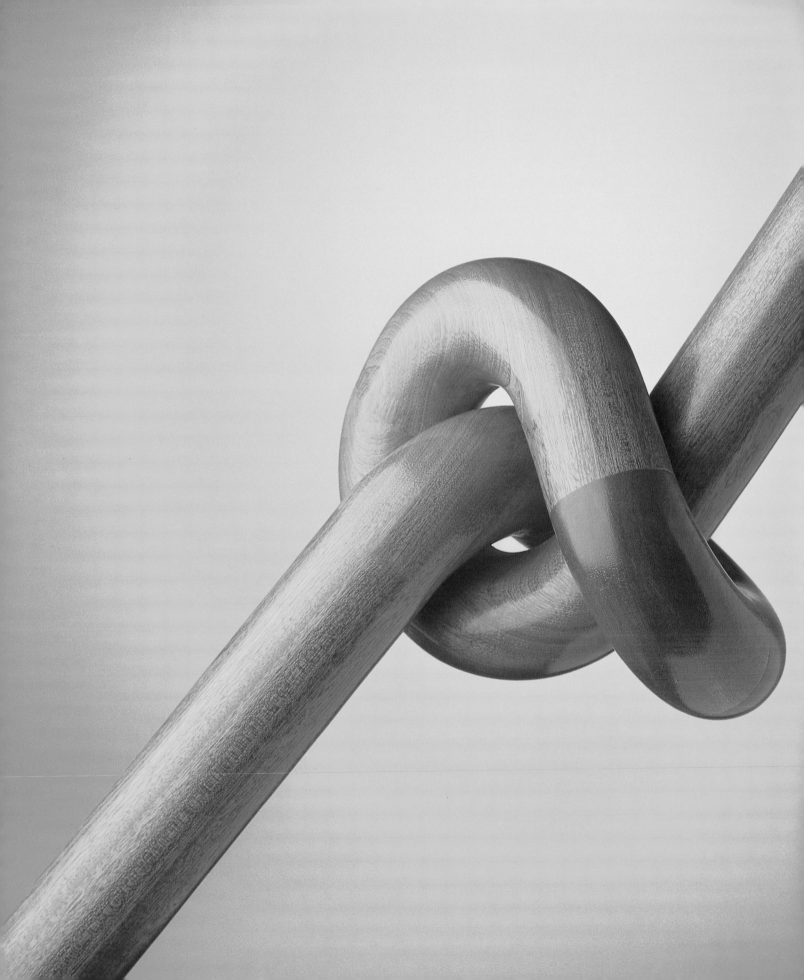

Get knotted

Ever wondered how arduous and expensive spiralling, curling handrails are to make? Haldane (UK) Ltd. prides itself on putting knots into wood rather than worrying about taking them out. This handrail may look super bendy ⬎ but it is actually produced by CNC-routing ⬎ technology from three pieces of wood. The CNC process can cut virtually any shape from a piece of timber and is described by Managing Director Adam Forrester as, 'like being handed the keys to the space shuttle when you are used to a Mini.'

Investment in the new technology ⬎ has paid off; Haldane can now manufacture any shape designers and architects throw at them. The full three-dimensional machining and routing technology means designers can manufacture almost any hardwood or softwood profile. It can be used for one-offs as well as multiples of identical pieces.

Dimensions	**Diameter: 50mm**
Material Properties	**Three-dimensional cutting technology**
	Low- to high-volume production
	Can accommodate a range of materials
	Designs can be cut straight from CAD files
Further Information	**www.haldaneuk.com**
Typical Uses	**Glazing beads; furniture components; handrails**

Sapele Timber Sample

Bacteria-killing organisms

Today, toothpicks are an unremarkable, disposable addition to most kitchen cupboards. But they used to be highly valued; an essential accessory for the well-to-do and often made from ivory and silver, as well as wood.

Toothpicks are produced at a rate of 15,000 per minute, or 2.5 billion per year ⟶. The automated process begins by cutting logs into 24 three-quarter-inch blocks which are steamed to 160°F to raise the moisture content. The logs are then sliced into veneers ⟶ on a lathe and dried to remove the excess moisture. The veneers are then separated according to whether they will be used to produce flat or round toothpicks.

For round toothpicks the veneer is fed into a moulding machine to produce round dowels. These are then fed into a pointing machine which consists of a series of belts and grinding stones. The picks are then polished and packed. Making flat toothpicks is a much faster process which produces up to 45,000 per minute.

So far, these valuable little stakes have not been replaced by other materials on a large scale. The natural bacteria-killing organisms in wood and its ability to soften make it the perfect material for exploring the oral landscape!

Material Properties	**Heavy, dense wood**
	Straight, fine-textured and close grain
	Good for steam bending
	Good workability but can be woolly
	Can be stained and polished
Sources	**Europe**
Further Information	**www.diamondbrands.com**
Typical Uses	**Toothpicks; principal material for birch plywood furniture; highly decorative veneers; general turnery; ice-cream spoons**

**Starburst Construction Made
with Thousands of Toothpicks
Designer: Tom Friedman**

Organic designs

Wood can be flexible ⬎, even curvy, when cut to thin sections and glued to a pre-existing form. Unlike working with plywood ⬎ sheets, where the direction of the grain is alternated with each layer of veneer ⬎, in this type of production the grain runs in the same direction. This process has enabled organic, undulating, rhythmic forms to be produced very easily.

In 1941, Ray and Charles Eames began a series of experiments into bent laminated plywood for the Organic Design in Home Furnishing competition. They continued to develop their working methods with an order from the American Navy for 5,000 moulded plywood leg splints, which led to the formation of the Plyformed Wood Company. Their use of plywood at the time fulfilled two main criteria: firstly it was economical, an important consideration just after the war; and secondly they created forms which could be moulded to the body.

The modular characteristic of the LCW chair is a result of the production of each part being addressed separately, allowing for complex and ergonomic forms to be easily produced.

LCW
Designers: Charles and Ray Eames
Manufacturer: Moulded Plywood
Division, Evans
1946

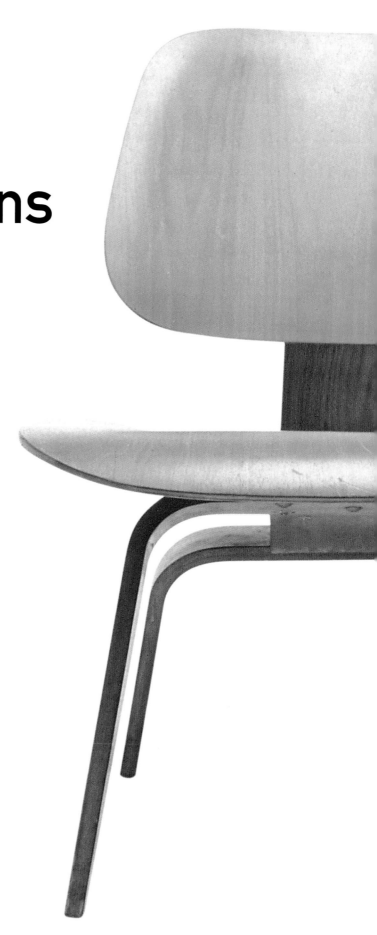

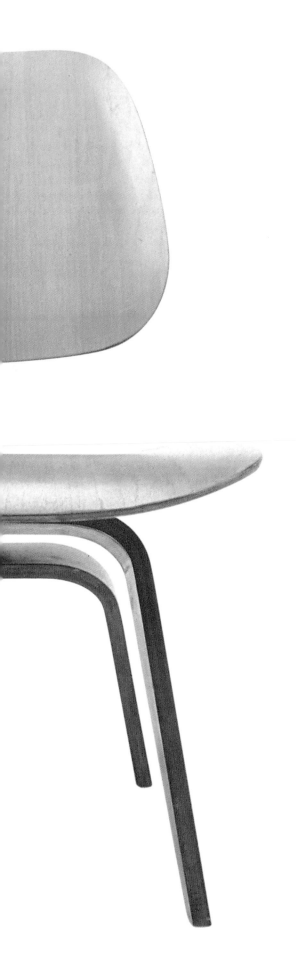

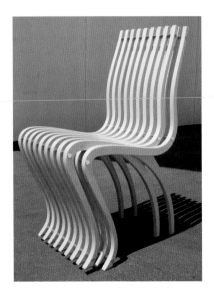

Schizzo Chair
Designer: Ron Arad
Originally Manufactured
by Vitra
1989

Dimensions	68 x 56 x 62cm
Material Properties	**Enables curves to be formed**
	Can be used for low- to high-volume production
	Economical use of material
Typical Uses	**Furniture; bows; any shape requiring a thick, curved form**

more: Flexible 022, 054, 058–059, 108, 115, 123; Plywood 054, 056, 060, 062–064, 070, 100, 123, 131; Veneer 016, 058, 060, 064, 068, 087, 091, 100, 106, 109, 112, 116, 127–128

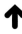

120
African hardwood

Butch Smuts is a wildlife ecologist based in South Africa. He has been turning dense African hardwoods like lead, wild olive and tamboti since 1998. He only uses timbers from abandoned dead trees for obvious ecological reasons. These very hard, dense woods ⬎ require special techniques for working and some pieces can take up to 17 hours to hollow.

It's rare to find a woodturner who isn't passionate about their craft and in love with their material. Some produce bowls that are never meant to function as containers, but exist only to show the natural beauty hidden beneath the bark. Many are on a continual search for the perfect form to capture the essence of a specific timber. But it is only relatively recently that woodturning has begun to embrace the more sculptural possibilities that are detached from a formal function.

Dimensions	**316 x 310mm**
Material Properties	**Very hard and dense**
	Excellent for turning
	Fine pore structure and even texture
	Not suitable for steam bending
	Difficult to work
Sources	**South and South East Africa**
Further Information	**www.flowgallery.co.uk**
Typical Uses	**Decorative veneers; interior furniture; carving; chess pieces; musical instruments**

Red Ivory Hollow Form
2001

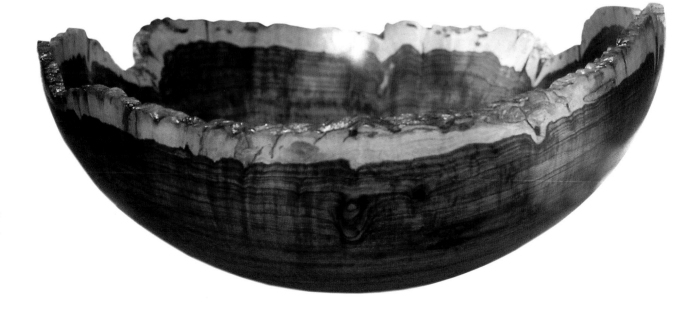

Prized product

There is a huge amount of ritual and labour that goes into finding just the right wood to make a really good pipe. It is a process which has more in common with cutting diamonds than with any other traditional type of wooden product.

Since opening its first pipe shop in London in 1907 Alfred Dunhill has established itself as maker of the finest pipes in the world. All Dunhill pipes are made from the wild white heather shrub, a plant that grows mainly in mountainous regions around the Mediterranean. The wood, which is harvested from this shrub, is taken from the part of the plant which is just below the soil level. The key to understanding why this type of wood is of such importance is knowing how the grain in the bowl of a pipe is affected by the heat.

In most types of wooden products the timber is selected for the strength and straightness of its grain. In pipes the opposite is true. If a straight-grained timber was used it would easily split along the grain by the heat of the burning tobacco. The type of timber used in pipes has a much less organised grain pattern, which means when it is heated there are no weak points that are likely to split.

To farm the wood is difficult. Hard, physical work in baking heat, and knowing what to look for, means few people are prepared to do it, leaving certain gypsy groups who gain permission to go into these uninhabited regions and select the right wood. Once the wood is harvested it is covered with sacks to prevent it from drying out and splitting into sections. At this point the timber is sold to a dealer who will have the wood cut into the most usable-sized pieces to maximise his return. But before the wood can be cut it has to be left a couple of years and hosed down every day in a dark cellar to the point where it grows.

Material Properties	**Irregular grain**
	Resistant to splitting
Sources	**Southern Europe**
Further Information	**www.pipes.com; www.whitespot.co.uk**
Typical Uses	**Watch dials; pens; handles of shaving brushes; chess pieces**

Pipe with Billiard-shaped Bowl and Windshield

Water-Jet Cut Birch Ply

122

Dimensions	64 x 48 x 46cm
Material Properties	**No burn marks; No post-cleaning of edges**
	Low tooling costs
	Can cut a range of materials
	Suitable for low- or high-volume production
	Self-assembly means low labour costs
	Very thin cutting line
	Corners can be cut with extremely tight radii
Further Information	**christopherlaughton@hotmail.com**
Typical Uses	**Furniture; domestic accessories; shop fittings; metal ice-skates; armour plating; glass**

Think of a jigsaw

Appropriate choice of methods and materials enables designers to produce small or large runs ↘ of products without heavy investment in tooling. For the Eclipse Laundry Bin, Christopher Laughton chose aeroply for its bendy, flexible ↘ properties and the water-jet cutting process. Wafer-thin structures can be created from the curled, twisted shapes — it is much like working with paper.

'After graduation, the interest from retailers but not manufacturers led me to investigate ways in which to manufacture the products myself. Cutting with a CNC water-jet machine has the advantage of minimal set-up costs and the ability to cut more than one sheet at a time. The finish on the cut piece is good enough not to need further finishing. This enabled me to produce the range efficiently with minimal waste of material and minimal manual labour,' says Christopher.

CNC water-jet cutting achieves shapes usually reserved for laser-cutting or CNC-routing ↘ machines (which avoid the toasted brown edge of laser-cutting and the frayed edges of CNC-cutting). It also avoids the browning of the ply on the underside due to reflection of the laser. This design capitalises on the flexibility of birch ply ↘, which allows for products to be stored and distributed flat for self-assembly.

Eclipse Laundry Bin
Designer: Christopher Laughton
1994

more: Mass production 021, 025, 047, 086, 116, 128, 131; Flexible 022, 054, 058–059, 108, 115, 118; CNC-routing 115; Plywood 054, 056, 060, 062–064, 070, 100, 118, 131

Dimensions	Outer chair: 89 x 89 x 70cm
Material Properties	High density and tolerance
	Biodegradable, 100 per cent recyclable
	Flame resistant (fire protection class B1)
	Excellent dimensional stability
	Made from mixed waste products without producing new waste
	High resistance to damp compared to fibreboard or MDF
Further Information	www.fasalex.com; www.strandex.com
Typical Uses	Cable channels; skirting boards; replacement for extruded plastic and long-profiled wooden shapes; electrical conduits; replacement for PVC on window frames

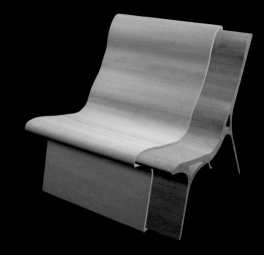

Sliding Chair
Designer: Yann Gafsou
2002

Intelligent material

'At the beginning of this project my wish was to study 20th-century furniture ⌄ design; to become more acquainted with the past in order to understand the present and the future. From Breuer's Wassily chair to Alvar Aalto's Number 43, these designs all exploited a new process, a local know-how, demonstrating properties of new materials at the same time. From then on, I really wanted to use a material as a guideline on this project; I wanted to let the material and the process guide me to an outcome,' says Yann Gafsou.

This is the rationale behind Yann's extruded wooden chair, made from what he describes as, 'a material for the 21st century'. It is ecological, economical and new. The design uses local waste materials and the manufacturing process produces no waste. As well as combining the manufacturing properties of plastics with the workability of wood this material is also biodegradable ⌄ and not restricted to wood fibres. Rice, soya beans, bamboo, straw and even peanuts can be used as a base. And if you are after a particular wood effect you can specify it as one of the many finishes available.

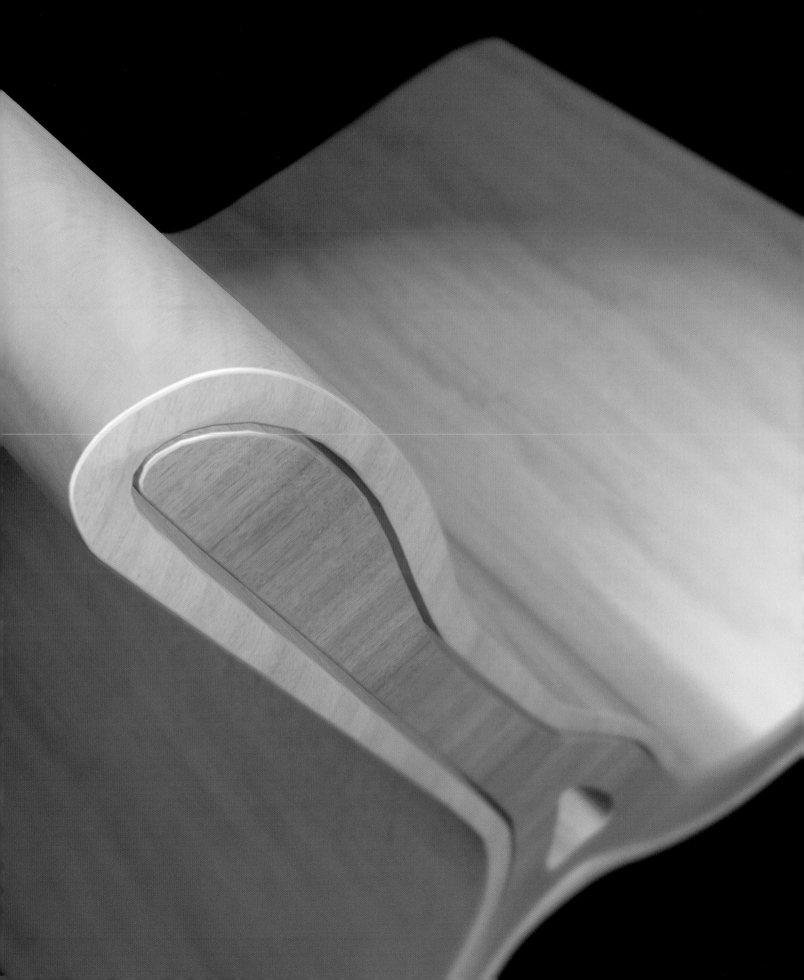

Old favourite

From school canteens to living rooms and TV dinners, these trays are understated archetypes of daily life. These ordinary, familiar objects are formed in a similar way to many plastic products: they are made from a flat sheet of wood into a three-dimensional shape in a way that resembles plastic vacuum forming. This particular pressed process results in a product that is almost impossible to break.

The combination of heat, pressure and polymer resins produces extremely strong, thin section designs. This can be seen in any number of furniture ⬊ designs, not only in their structure but in surface designs from the 1950s and 1960s when it was fashionable to emboss wood with fake snake-skin patterns.

Dimensions	48 x 34 x 5cm
Material Properties	**Allows for shallow forms**
	Extremely durable; Dishwasher safe
	Heat-resistant
	Excellent chemical resistance
	Printable surface
Further Information	**sales@neviluk.com; Tel: +44 (0) 1322 443143**
Typical Uses	**Furniture; embossed patterns for surface decoration; furniture inlays; automotive interior mouldings**

Pressed Laminated Tray
Manufacturer: Neville and Sons

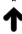

Borrowed technology

Layering wood for the watertight construction of boats has been developed and practised by craftsmen throughout history. But the Mussel Bathtub is made of wood which has been treated to keep the water in rather than out.

The final design is based on two years of development by designers and boat-builders, and applies construction techniques specific to boat-building. The technology ⌄ involves glass-reinforced plastic over which small pieces of 3mm saw-cut veneer ⌄ are formed. The wooden bath heightens the sensual experience of bathtime by providing a pleasant aroma as well as a tactile, warm surface to lie against.

The surface of the wood is protected and sealed with oil or varnish. This also protects skin from that rough sensation akin to eating out of the pan with a wooden spoon.

Dimensions	24 x 150cm; Capacity: approx 380 litres
Material Properties	**Rigid construction**
	Lightweight structure
	Oil and varnish provide watertight construction
	Versatile production method
Further Information	**www.gnausch.de**
Typical Uses	**Yacht construction**

Bademuschel Bathtub
Designer and Maker: Tilo Gnausch
2001

↑ more: Technology 098, 112, 115; Veneer 016, 058, 060, 064, 068, 087, 091, 100, 106, 109, 112, 116, 118, 128

Wood is not generally thought of as a mass-production ⩗ material. Plastic definitely, glass and metal for sure, but wood does not have a history of being exploited to make millions of identical products. However, the match is an interesting exception.

Matches are generally made from aspen and poplar ⩗. First the wood is cut into sheets of veneer ⩗ which are chopped into square splints and fed into a series of holes within metal plates. These plates carry the matches through the various stages of production: the next being a dip in a chemical bath to prevent afterglow. They are then taken through paraffin to help them burn more easily. Lastly, the heads are applied. Machines can yield approximately 50 million matches per day.

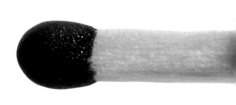

50 million per day

Material Properties	Coarse texture
	Rich, straight grain
	Good workability and finishing
	Good resistance to water
	Excellent for steam bending
Sources	Europe; Asia Minor; North Africa
Typical Uses	Furniture; flooring; boat-building; wine and whiskey barrels; interior furniture; frames; doors; panelling; church pews; carving

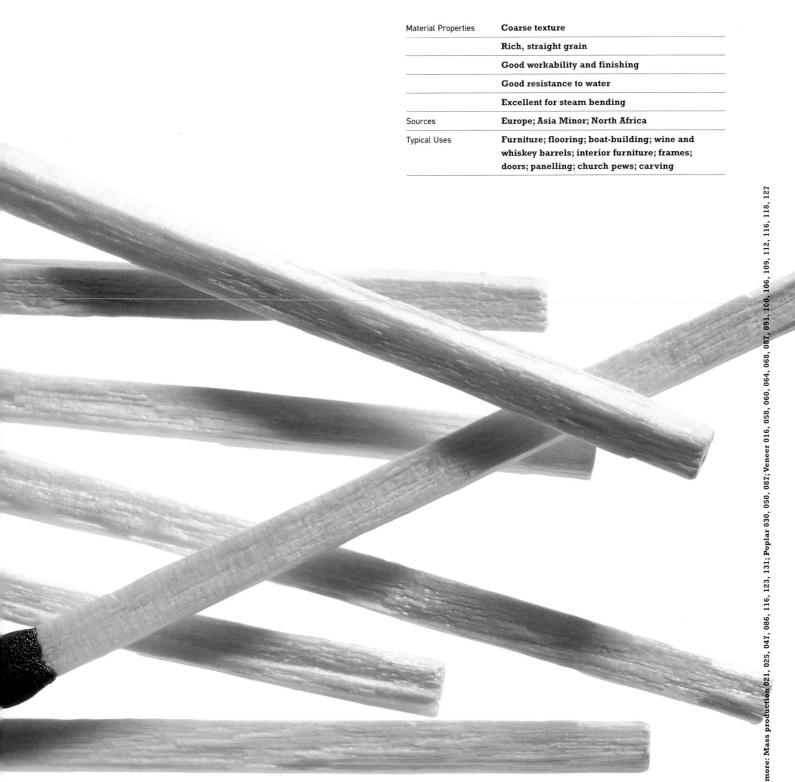

Added value

Electrical sockets are not beautiful objects.
They serve a function. We ignore them and let
them get on with their job unseen and unheard.
Our ability to manufacture mass-produced ↘,
everyday, utility products like electrical plugs
has standardised these practical items into a
state of mundane disinterest.

Sockets are ignored on any level other than
practical but this design asks to be noticed. To
avoid the large tooling costs involved in plastic
injection moulding, the designer has opted for
shina plywood ↘ and handmade production.

The craftsmanship of the production and
the natural surface decoration of the wood
contrasts effectively and livens up a familiar
and dull product. These qualities, combined
with the proportion and detailing, give the
socket aesthetic value, bringing it out from its
hiding place under the sofa to become a new
proud domestic accessory.

Concents Wooden Socket
Designer: Koichi Futatsumata
Manufacturer: Case Real
1998

Dimensions	10 x 10 x 10cm
Material Properties	Fine pale grain
	Easy to carve
	Good stability in plywood form
	Can produce a good finish
Sources	Mainly grown and produced in Northern Japan
Further Information	www.imcclains.com
Typical Uses	Wood block carving; pattern making; cutting boards for leatherwork

more: Mass production 021, 025, 047, 086, 116, 123, 128; Plywood 054, 056, 060, 062–064, 070, 100, 118, 123

The following technical table sets out to provide the basic guidelines necessary for selecting and using woods. It cannot claim to be definitive but includes details of the wood types most commonly used. In order to satisfy the wide range of uses it is helpful to understand the different characteristics of the species, select those that are appropriate to the requirement and use them correctly.

Different timber species have a huge range of natural characteristics that make them especially suitable for specific uses. Some species are very hard and strong, others have fine grain and can be machined extremely accurately. Some are very durable in adverse conditions, others are less so and require preservative treatment to be suitable for external use. Some are decorative in appearance, others are plain. The former may need to be cut in a specific way to achieve this. Some timbers are available in large quantities, as long lengths, wide boards and/or as veneers; others are less readily available and may command higher prices as a result.

Colours ranging from pale cream to dark brown are typical of the species included in the table that follows but it should be remembered that, as a natural material, there will often be variations. If significant colour variations are unacceptable, some species are preferable to others and advice should be sought from the joinery supplier.

Classification of Wood

Hardwoods and softwoods

These terms are historical and must be regarded as a general classification to which there are many exceptions. The term 'hardwood' is applied to timber from deciduous and evergreen broad-leaved trees. Softwood is used to describe timber from coniferous or needle-leaved trees. Hardwoods are not necessarily harder (ie have greater density) than softwoods; for example, the Douglas fir, a softwood, has the same density as African mahogany (a hardwood) and many other hardwood species have lower densities.

There are in practice few end uses which cannot be satisfied by softwood species. What cannot be replicated is the visual attraction of the decorative hardwoods and, for specific end uses, the hardness and strength of the most dense hardwoods.

Temperate and tropical timbers

Most softwoods come from the temperate regions of the world, including the UK, Scandinavia, Russia and North America. In general, the lower the winter temperatures, the more slow-growing the trees are and the better the quality of the softwood. Almost all softwoods are now cut from replanted and managed forests. It takes between 60 and 80 years for a typical conifer or pine tree to reach sufficient size to produce useful timber and this period can be considered a typical crop cycle. Many temperate hardwoods are attractive and suitable for numerous purposes, although many are not durable and therefore unsuitable for external use unless preservative-treated. The majority of durable hardwood species come from Africa, Central and South America and the Far East. The export of timber is very important to the countries concerned and the majority of them are in the process of setting up and managing their resources in a sustainable manner. This is likely to increase the export of some unfamiliar timber species as alternatives to those more commonly specified.

A small number of tropical timber species are included in the CITES (Convention on International Trade in Endangered Species) list. This has two significant categories: Appendix 1, listing where trading is prohibited and Appendix 2, where the species may become threatened if trading is not controlled and monitored. Trade in Appendix 2 species requires an export licence to be issued by a government authority in the country of origin and an import permit in the receiving country.

No Appendix 1 timbers are included in the tables that follow. Where Appendix 2 timbers are included, the CITES listing is noted in the Comments column.

Preservative treatment

The natural durability of wood varies widely depending upon the species. Many of the most commonly used species have only modest natural durability when used externally. Pressure impregnation enhances the natural durability making such timbers suitable for use in exposed external conditions. Some species are more easily treated than others due to the cell structure of the timber.

There are three types of preservative treatment:
1. CCA, which is waterborne, is ideally suited to structural timbers, cladding, fencing and similar external applications. CCA treatment is applied to the timber in a pressure tank.

2. Organic solvent is preferred for joinery use where waterborne chemicals can cause increased moisture content, the possible distortion of accurate profiles and roughening of surface finish. The best method of organic solvent treatment is by vacuum-induced impregnation after the component parts are cut to length and profiled. Dipping can provide a satisfactory solution for some species and some end uses. Brush treating is only suitable for remedial treatment of previously treated material after drilling or cutting.

3. Boron treatment is a water-based treatment which is applied to the timber by diffusion before it is dried. The timber is preserved throughout the cross-section and can be machined, cut or shaped without needing further treatment. Boron is applied by spraying or dipping the green (unseasoned) timber. Diffusion takes place whilst the timber is close stacked and takes from a few days to a few weeks depending upon the thickness. When full penetration is acheived the timber is air- or kiln-dried in the normal manner. Because it can only be applied to green timber, Boron treatment is less readily available than the other types.

CCA treatment generally leaves the timber a pale grey/green colour. Organic solvent and Boron treatments are usually colourless.

Wood which is to be used for wall or ceiling linings can also be treated with chemicals to improve its surface spread of flame resistance. Most timber (all species with a density of 400kg/m^3 or more) has a Class 3 classification when tested to 88 476. Treatment by impregnation or surface application can upgrade this to Class 1 or Class C as defined in the building regulations.

Moisture content

Specifying a moisture content appropriate to the end use of the timber is important in order to avoid problems resulting from shrinkage or swelling after installation. Timber will eventually reach an equilibrium moisture content which equates to its environment. As the moisture content changes it will be accompanied by some proportional movement across the grain of the wood. A correct initial moisture content allied to good design will generally prevent this causing problems. External joinery should have an initial moisture content between 13 and 19 per cent; internal joinery in a heated building should have an initial moisture content between 8 and 14 per cent.

Dimensional stability

All timbers have a lower ratio of movement across a radial surface (quarter sawn) than across a tangential surface (flat sawn or crown cut). For timbers that are dimensionally stable, this ratio is low. Conversely, in timbers with higher movement characteristics the ratio is higher. However, most commonly available species have an average ratio of approximately 1:2. Whilst these differences can be important (for example, a radially cut wide board is likely to be less prone to cupping than a similar board cut tangentially), they are largely negated if the initial moisture content is correct and is maintained until the work is completed and the building is in commission. When wide, flat surfaces are wanted, the use of edge-laminated sections approximately 100mm in width to make up the wide piece will generally provide a more dimensionally stable end product.

Radial and tangential cutting also has an effect on the appearance of the wood. Radial cutting produces an even appearance with a generally parallel grain pattern, tangential cutting exaggerates the grain of the wood which can be very decorative in some species.

Availability

When long lengths (more than about 3.5m for most species) or wide boards (more than 150mm) are required it is important to remember that the size of timber which is available inevitably relates to the size of the tree from which it is cut. Unusually long or wide pieces may be difficult to obtain and may be disproportionately costly. The use of laminated sections and veneers can help in overcoming the problems and should also provide a more stable end product. The availability of clear grades of softwood also relates to the size of the tree. European red and white woods are generally cut from trees of modest size making it more difficult to obtain commercial quantities of clear (knot-free) timber. Timbers such as Douglas fir, hemlock and southern yellow pine frequently come from larger trees, providing larger diameter sawlogs from which clear grades are more readily available. The cost of wood is affected by market conditions, exchange rates, availability and the quality required. Some timber species have higher wastage factors than others in component manufacture, especially if accurate matching of colour and grain is required. The amount of wastage inevitably affects the cost of the finished work and it may be more economical to change to an alternative, but possibly more expensive, timber to reduce the wastage factor.

Finishes

The main functions of any finish are to seal the surface of the wood against moisture, to make cleaning easier and to provide the surface colour and texture desired for the end use. For wood used internally there are many options including oils, waxes, clear varnishes, decorative translucent stains and opaque paints and stains. External finishing systems are generally required to contribute to the long-term durability of the wood and be resistant to UV light, water and temperature variations. Translucent and opaque stains and paint finishes which are specially formulated for external use are the preferred choice. Clear finishes such as varnish should not be used externally since they weather badly and need considerable and frequent maintenance to keep their appearance and protective qualities. Finishes can affect the colour of the wood. Some wood species have special finishing requirements or are particularly suitable to receive paint or stain finishes; these are noted in the comments section of the following table.

Technical Information

Notes The following table includes information on a selection of the more commonly specified wood species together with some which have become readily available in recent years. The list should not be considered definitive since many factors can affect availability.

Durability The durability classification shown is based upon research carried out by the Building Research Establishment (BRE). This is based upon sections of timber buried in the ground and therefore refers to timber in ground contact which is a very arduous condition. In less hazardous conditions the same durability rankings will apply although the service life will be longer. The grades are as follows:

Durability / Grade	average life at 50 x 50mm stakes in ground contact
Perishable	less than 5 years
Non-durable	5–10 years
Moderately durable	10–15 years
Durable	15–25 years
Very durable	over 25 years

The actual conditions of use should be considered when selecting a timber. There can be circumstances where a timber graded as non-durable will perform very satisfactorily without treatment in an external situation. The durability grade applies only to the heartwood; sapwood of all species should be considered non-durable or perishable.

Further information on the natural durability of timber is included in BRE Digest 296.

Treatability The natural durability of wood can be uprated by appropriate preservative treatment; some species are more easily treated than others. Timbers classified as 'fair' may need longer impregnation cycles and lateral penetration will not usually be greater than about 3 to 6mm. Timbers classified as 'poor' will absorb only very small amounts of preservative with minimal lateral penetration.

Density The density figures quoted are for timber at around 15 per cent moisture content. The density of a species provides useful general guidance to its strength, resistance to abrasion and impact.

Moisture movement Refers to the dimensional changes in service which may result from variations in atmospheric conditions after the timber has been dried to a moisture content appropriate to the end use.

For most purposes the amount of movement is not significant but timber with small movement characteristics should be considered where large pieces or areas of timber are used in locations where variations in humidity are likely.

Workability Refers to the ease of working; a 'difficult' classification timber will need greater care in machining especially where very accurate profiles and a high quality finish are required.

Availability Availability is based on the best available information at the time of publication. Long length means greater than about 3.5m; wide board means greater than 150mm.

Classification of Wood and Technical Information reproduced by kind permission of the British Woodworking Federation.

COMMON NAME Alternative name Latin name Origin	Durability Treatability	Density kg/m³ Moisture movement	Workability Texture	Availability (long lengths) (wide boards) (veneers)	Typical uses	Comments
CEDAR OF LEBANON Atlas, Atlantic cedar deodar Cedrus libani Europe	durable	580 medium/ small	good	limited (V)	int. joinery	Decorative timber, has a high wastage factor due to prevalence of knots. Has a strong cedar smell. Takes paint and varnish well but degreasing may be required before coating.
DOUGLAS FIR Colombian/Oregon pine Pseudotsuga menziesii N. America, Europe	moderately durable fair	530 small	good good	good (LL) (WB) (V)	construction ext. joinery (T) int. joinery furniture fittings	Clear grades available. Tangential sawn timber has attractive grain pattern. Finishing needs care due to resin content. Damp contact with iron should be avoided.
EUROPEAN REDWOOD Scots pine Pinus sylvestris Scandinavia, Russia, UK	non-durable good	510 medium	good medium	good (LL)	construction ext. joinery (T) int. joinery furniture	General-purpose timber for structural and joinery use. Clear grades difficult to obtain in commercial quantities.
EUROPEAN WHITEWOOD Common/European spruce Picea abies, Abien alba Scandinavia, Russia, UK	non-durable fair	470 medium	good medium	good	construction ext. joinery (T) int. joinery staircases	General-purpose timber. Usually has more, but smaller, knots than E. Redwood. Complex joinery profiles difficult to machine to good surfaces.
HEMLOCK, WESTERN Pacific/BC hemlock Tsuga heterophylla N. America	non-durable fair	500 small	good medium	good (LL)	construction ext. joinery (T) int. joinery furniture	Clear grades available. Availability of straight-grained timber makes it good for door stiles and rails. Difficult to finish smoothly.

COMMON NAME Alternative name Latin name Origin	Durability Treatability	Density kg/m³ Moisture movement	Workability Texture	Availability (long lengths) (wide boards) (veneers)	Typical uses	Comments
PARANA PINE Brazilian pine Araucaria angustifolia S. America	non-durable/ perishable poor	550 medium	good fine	limited (LL) (WB) (V)	int. joinery staircases	Increasingly difficult to obtain. Attractive when clear finished. Can distort with changes of moisture content, one of few timbers which shrinks in its length.
SOUTHERN PINE Pitch/southern yellow pine Pinus palustris N. America	moderately durable fair	590 medium	good good	good (LL) (WB) (V)	construction ext. joinery (T) int. joinery flooring	Clear grades available. Birch pine was traditionally used for ships, masts and spars, church pews and construction. Attractive when clear finished. Degreasing may be required before coating.
SPRUCE White, silver, red, sitka spruce Picea spp. N. America, UK	non-durable fair	450 small	good coarse	good	construction	General purpose construction timber. Commonly used for carcassing and pallet manufacture.
WESTERN RED CEDAR Thuja plicata N. America	durable N/A	390 small	good coarse	good	ext. joinery int. joinery ext. cladding	Soft for general joinery use. Weathers to attractive grey colour if untreated. Ferrous fixings cause staining; use copper, bronze or sherardised fixings.
YELLOW PINE White pine, Quebec pine Pinus strobus N. America	non-durable fair	420 small	good fine	good	ext. joinery int. joinery furniture pattern-making	Lighter and softer than other pines but very low shrinkage factor compared with other North American softwoods. Suitable for internal joinery; also used for carving and musical instruments.

COMMON NAME Alternative name Latin name Origin	Durability Treatability	Density kg/m³ Moisture movement	Workability Texture	Availability (long lengths) (wide boards) (veneers)	Typical uses	Comments
YEW Taxus baccata Europe, UK	durable N/A	670 small	difficult medium	very limited (V)	furniture int. joinery	Attractive timber. Only limited quantities and small sizes generally available. Veneer is decorative. A very 'hard' softwood. Has high wastage factor.
AFRORMOSIA Kukrodaa, Assamela Per, cops, sefata Africa	very durable N/A	710 small	medium fine	limited (LL) (WBI) (V)	ext. joinery int. joinery furniture fittings flooring	Availability is becoming restricted. Colour darkens on exposure. Acidic timber corrodes ferrous metals in damp conditions causing staining. Degreasing may be required before coating.
AFZELIA Osassie Afzelia spp. W. Africa	very durable N/A	830 small	medium coarse	limited (LL) (WB) (V)	ext. joinery int. joinery flooring	Attractive timber. Very hard and difficult to damage. Takes clear finishes and polishes well.
AGBA Mobo, Tale Gosswellerodendron W. Africa	very durable N/A	510 small	good medium/fine	medium (LL) (WB)	ext. joinery int. joinery furniture fittings	Similar to Idigbo. Good for moulding. Takes stain finishes well. Degreasing may be required before coating.
AMERICAN YELLOW Poplar Talipmood Liriodendron Tapfore N. America	non-durable poor	510 medium	medium fine	good (LL) (WB) (V)	construction int. joinery mouldings	Good general internal joinery timber. Provides substrate for high quality paint finish. Prone to staining; must be kept dry.

COMMON NAME Alternative name Latin name Origin	Durability Treatability	Density kg/m³ Moisture movement	Workability Texture	Availability (long lengths) (wide boards) (veneers)	Typical uses	Comments
ASH, AMERICAN Black, white, Greek ash Frarinas spp. N. America	perishable fair	560 medium	good good	good (LL) (WB) (V)	int. joinery furniture fittings	Decorative timber. Density varies due to species variation. Less dense wood is good for furniture and finishes well.
ASH, EUROPEAN White, olive ash Frexinas excelsior Europe, UK	perishable poor	710 medium	good medium/ coarse	good (V)	int. joinery furniture fittings	Generally better texture than American Ash. Olive ash has decorative dark heartwood streaks. Good for bending.
BEECH, EUROPEAN English, Danish, French etc. Fagas sylvatica Europe, UK	perishable fair	720 large	good fine/medium	good (LL) (WB) (V)	int. joinery furniture fittings flooring	Plain, cream/pale brown coloured timber. Good for bending and hard wearing.
BEECH, EUROPEAN (steamed) Fagas sylvatica Europe, UK	perishable fair	720 large	good fine/medium	good (LL) (V)	int. joinery furniture fittings	Steam treated as part of the kilning process and has an even pink colour. Good for bending and hard wearing.

COMMON NAME Alternative name Latin name Origin	Durability Treatability	Density kg/m³ Moisture movement	Workability Texture	Availability (long lengths) (wide boards) (veneers)	Typical uses	Comments
BUBINGA Kevezingo, Essingang Guibourta spp. W. Africa	moderately durable N/A	880 fine	 fine	limited (V)	as a veneer	Decorative veneer. When rotary-cut which gives a different appearance; veneer is called Kevazingo.
CEDAR, SOUTH AMERICAN Brazilian cedar Cedrela spp. Central and S. America	durable N/A	470 small	good medium	good (LL) (WB) (V)	ext. joinery int. joinery furniture fittings	Similar appearance to mahogany and can be used as an alternative. Polishes well and can be coloured to match other timbers.
CHERRY, AMERICAN Black cherry Prunus serontina N. America	moderately durable	580 medium	good fine	good (LL) (WB) (V)	ext. joinery furniture fittings	Attractive timber. Has high wastage factor due to sap. Colour darkens rapidly if a UV inhibitor finish is not used.
CHERRY, EUROPEAN Gean, wild cherry Prunus aviam Europe	moderately durable	630 medium	good fine	limited (V)	furniture fittings	Attractive furniture timber. Only small sizes available. More colour contrast than American cherry. May need degreasing before coating.
CHESTNUT, SWEET Spanish, European chestnut Casstanea sativa Europe	durable N/A	560 large	good medium	limited (V)	furniture ext. joinery int. joinery	Acidic timber. Corrodes ferrous metal fixings causing staining. Attractive; a possible alternative to oak but without the 'flame' figure.

COMMON NAME Alternative name Latin name Origin	Durability Treatability	Density kg/m³ Moisture movement	Workability Texture	Availability (long lengths) (wide boards) (veneers)	Typical uses	Comments
ELM, AMERICAN Red elm, slippery elm Ulmao rubra N. America	non-durable poor	670 medium	medium medium	limited (V)	int. joinery furniture fittings	Attractive timber, less coarse-grained and easier to finish than European elm. Available only in small sections.
ELM, EUROPEAN Ulmus spp. Europe, UK	non-durable poor	580 medium	good coarse	limited	furniture	Supply of UK-sourced timber difficult due to the effect of Dutch elm disease. Can be difficult to get good finish.
GREENHEART Ocotea rodiaei Guyana	very N/A	1040 medium	difficult coarse	variable (LL) (WB)	heavy-construction bridges sea defences	Very large sections available. Will not float. Care in working necessary – splinters are poisonous. Available chipping dry only for construction use.
HYEDUA Ogea, oziya, faro Daniellia ogea W. Africa	perishable poor	420 small to 530	difficult coarse	variable	int. joinery furniture fittings	Decorative timber used as substitute for rosewood in solid sections. Generally only available in small sections.
IDIGBO Emeri, framire Terminalia ivorensis W. Africa	durable N/A	560 var small	medium medium	variable	ext. joinery int. joinery	Similar in appearance to Agba. Takes stain finishes well. Corrodes ferrous metal fixings. Will match with oak veneer to economise on solid sections.

COMMON NAME Alternative name Latin name Origin	Durability Treatability	Density kg/m³ Moisture movement	Workability Texture	Availability (long lengths) (wide boards) (veneers)	Typical uses	Comments
IROKO Odum, mvule, kambala, abang Chloropbora excelsa W. Africa	very durable N/A	660 small	medium medium	medium (LL) (WB) (V)	construction ext. joinery int. joinery furniture	Very strong and durable. Can contain calcium carbonate (called stone) deposits. Resistant to chemicals, hence used for laboratory worktops. May need degreasing before coating.
JELUTONG Dyera costulata S.E. Asia	non-durable good	470 small	good fine	medium	mouldings pattern- making	Too soft for general joinery use. Very stable. Good for small, accurate mouldings.
KERUING Gurjun, kruen Dipterocarpus spp. S.E. Asia	moderately durable poor	740 var large /medium	medium coarse	medium (LL)	heavy construction sills/ thresholds	Resin exudation can be a problem when finishing. Preservative treatment recommended for external construction. Density varies with species. Available shipping dry only for construction use. May need degreasing before coating.
LIME, EUROPEAN Tilia spp.	perishable 	560 medium	good fine	very limited	carving turnery	Does not taint food. Traditionally used for butchers' chopping blocks. Mild grained timber, good for carving.

COMMON NAME Alternative name Latin name Origin	Durability Treatability	Density kg/m³ Moisture movement	Workability Texture	Availability (long lengths) (wide boards) (veneers)	Typical uses	Comments
MAHOGANY, AFRICAN **Khaya** **Khaya spp.** **W. Africa**	moderately durable poor	530 small	medium medium	medium (LL) (WB) (V)	ext. joinery int. joinery furniture	Available longer and wider than most other timbers. Very stable. Often used to fabricate table or bench tops.
MAHOGANY, AMERICAN **Brazilian, Belize etc** **Swietenia macropbylia** **Central and S. America**	durable N/A	560 var small	good good	medium (LL) (WB) (V)	ext. joinery int. joinery furniture	Brazilian mahogany is usually easier to work to fine profiles than other American mahoganies which are harder and darker in colour.
MAPLE, HARD **Rock, sugar, black maple** **Acer saccbarum** **N. America**	non-durable poor	655 medium	medium fine	medium (LL) (WB) (V)	furniture flooring turnery	Attractive timber. Very resistant to abrasion. Difficult to stain satisfactorily. Polishes well.
MAPLE, SOFT **Red, silver maple** **Acer rubrum, sacobarinum** **N. America**	non-durable poor	550 medium	medium fine	limited (V)	int. joinery furniture turnery	Very similar to hard maple but grain less dense.

COMMON NAME Alternative name Latin name Origin	Durability Treatability	Density kg/m³ Moisture movement	Workability Texture	Availability (long lengths) (wide boards) (veneers)	Typical uses	Comments
MERANTI, DARK RED Nemeso Shorea spp. S.E. Asia	mod, durable/ non-durable fair	710 small	medium medium	good (LL) (WB) (V)	ext. joinery int. joinery furniture fittings	Often incorrectly described as Philippine mahogany; it is a different species with differing characteristics.
OAK, AMERICAN RED Guercus spp. N. America	non-durable poor	790 medium	medium medium	good (LL) (WB) (V)	int. joinery furniture fittings	Coarser, more open texture than white oak. Colour can vary from pink to red/brown but more red than other oak species.
OAK, AMERICAN WHITE Guercus spp. N. America	durable N/A	770 medium	good good	good (LL) (WB) (V)	ext. joinery int. joinery furniture fittings flooring	Good decorative timber which finishes well. Care is necessary when specifying for external use since timber is commonly imported at low moisture content. May need degreasing before coating.
OAK, EUROPEAN Guercus spp. Europe, UK	durable N/A	720 medium	good good	variable (LL) (WB) (V)	construction ext. joinery int. joinery furniture	Decorative timber. High wastage factor. Acidic timber corrodes ferrous metals causing staining. Lead can suffer serious deterioration when adjacent to or in contact with oak.
OBECHE Arere, wawa, samba Triplochiton Soleroxylon W. Africa	non-durable poor	390 small	good (V) medium	limited (V)	furniture mouldings	Soft for general joinery use. Very stable. Good for small, accurate mouldings.

COMMON NAME Alternative name Latin name Origin	Durability Treatability	Density kg/m³ Moisture movement	Workability Texture	Availability (long lengths) (wide boards) (veneers)	Typical uses	Comments
OPEPE Kusia, badi, bilinga Nauclea diderrichii W. Africa	very durable N/A	750 small	medium coarse	variable (LL) (WB) (V)	heavy construction	Hard and durable timber, often used for sea defence work. Available shipping dry only for construction use.
PADAUK Cammood, barwood Pterocarpus soyauxii W. Africa	very durable N/A	740 small	good good	limited (LL) (WB) (V)	ext. joinery int. joinery furniture carving	Very decorative timber which machines and finishes well. Strong red colour.
PURPLEHEART Peltogyne spp. Central and S. America	very durable N/A	880 small	medium/ difficult medium	limited (LL) (WB)	heavy construction flooring	Hard and durable timber, often used for sea defence work. Available shipping dry only for construction use.
RAMIN Melawis Gonystylus macrophyllum S.E. Asia	perishable good	670 large	medium medium	very limited	mouldings	Difficult to obtain in very small quantities because of limitations on export of sawn timber from producing countries.
SAPELE Entandrophragma cylindricum W. Africa	moderately durable poor	640 medium	medium medium	good (V)	int. joinery furniture fittings flooring	Has a pronounced stripy pattern when quarter sawn.

COMMON NAME Alternative name Latin name Origin	Durability Treatability	Density kg/m³	Moisture movement Workability	Availability (long lengths) (wide boards) (veneers)	Typical uses	Comments
SYCAMORE **Sycamore plane, great maple** **Acer pseudoplatanas** **Europe, UK**	perishable good	630 medium	good fine	medium (V)	int. joinery furniture fittings turnery	Attractive timber for internal joinery. Finishes well. Very pale colour; needs care in kilning to avoid colour changing from white to grey.
TEAK **Tectona grandis** **Burma, Thailand**	very durable N/A	660 small	medium medium	good (LL) (V) fittings	ext. joinery int. joinery furniture	Attractive timber, very resistant to chemicals. Oily – needs care in finishing; requires degreasing before coating.
UTILE **Sips, assie** **Entandropbragma utile** **W. Africa**	durable N/A	660 medium	medium medium	good (LL) (WB) (V)	ext. joinery int. joinery furniture fittings	Attractive timber, similar in appearance to sapele but milder to work and finishes better.
WALNUT, AFRICA **Dibetto, apopo, lovoa** **Lovoa trichilioides** **W. Africa**	moderately durable non-durable poor	560 small	medium good	limited (LL) (WB) (V)	int. joinery furniture fittings carving	Decorative appearance. Takes stain well. Good stable timber for internal joinery. May need degreasing before coating.

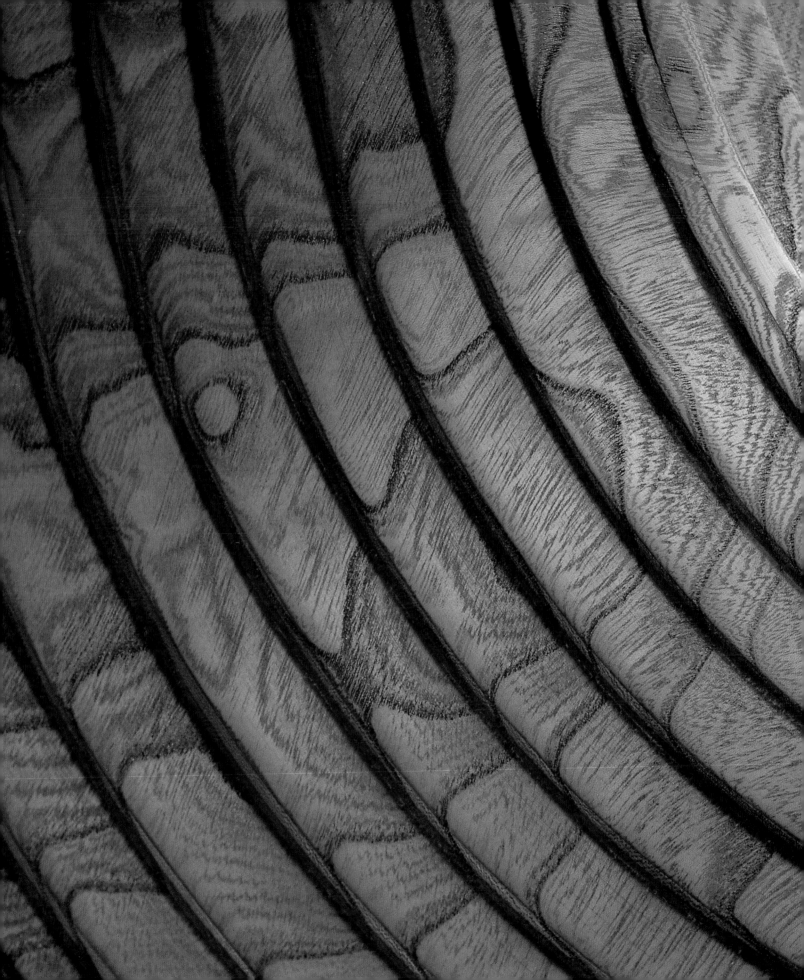

Materials

www.britishplywood.co.uk

Business-to-business manufacturer of bespoke fire-resisting door blanks and plywood.

www.unionveneers.com

Largest veneer company in the UK.

www.weyerhaeuser.com

International forest products company that grows and harvests trees. Sells logs, building products, wood chips, pulp, paper and packaging. Collect and recycles wastepaper, boxes and newsprint. Builds single- and multi-family homes and develops land.

www.plyboo-america.com; www.plyboo.nl

Plyboo is the first flooring material to be made exclusively from hard and mature bamboo harvested from controlled forests.

Environmental

www.greenpeace.org

An independent campaigning organisation that uses non-violent, creative confrontation to expose global environmental problems and to force solutions which are essential to a green and peaceful future.

www.efi.fi

An independent non-governmental organisation conducting European forest research.

www.certifiedwood.org

The Certified Forest Products Council (CFPC) promotes forest certification as a tool to conserve, protect and restore the world's forests. CFPC has created the Certification Resource Center to help you to discover certified products and forests, compare forest certification systems, expand your knowledge and take action!

www.ffcs-finland.org

A forest certification system suitable for local conditions has been established in Finland known as the FFCS (Finnish Forest Certification System). FFCS certification indicates impartially and reliably that Finland's forests and forest ecosystems are being sustainably managed.

www.cites.org

The International Trade Endangered Species of Wild Fauna and Flora.

www.wcmc.org.uk/trees

The World Conservation Monitoring Centre, in association with the IUCN Species Survival Commission and a network of experts, has identified over 8,000 tree species which are threatened with extinction at a global level. This survey, supported by the Government of the Netherlands as part of the Conservation and Sustainable Management of Trees project, is the first of its kind to assess the conservation status of tree species worldwide. Information on individual species is recorded in the Tree Conservation Database and includes IUCN red list category, information on distribution, uses, ecology, threats and conservation measures. Summary information on individual species is published in the World List of Threatened Trees.

www.ecotimber.co.uk

An independent company with more than ten years of experience in sourcing and marketing timber from well-managed sources: environmentally appropriate, socially beneficial, and economically viable.

www.earthsourcewood.com

Earthsource-certified wood products originate from forests that are FSC-certified for their sustainable harvest practises. One of the largest inventories of certified woods.

www.fsc-uk.demon.co.uk

FSC-labelled wood products and how to find supplies of FSC timber.

www.countrylovers.co.uk/fun/oldtrees.htm

Information on visiting, living and working in the UK countryside.

www.metla.fi/metinfo/index-en.htm

Research-based, forest-related information services.

Distribution

www.itto.or.jp/Index.html

The International Tropical Timber Organization (ITTO) was created by treaty in 1983 to provide an effective framework for consultation among producer and consumer member countries on all aspects of the world timber economy within its mandate.

www.timberweb.com

Excellent for searching worldwide wood manufacturers and suppliers.

www.hardwoodinfo.com

The Hardwood Information Center is run by the Hardwood Manufacturers Association. Facts, tips and useful advice about US hardwoods and hardwood products.

www.holland-timber.nl/uk

Importers and exporters of hardwoods for furniture, woodworking, broomhandles, flooring and many other timber-related industries.

www.mtc.com.my

Malaysian Timber Council.

www.nmw.ac.uk/ectf/Default.htm

The Edinburgh Centre for Tropical Forests (ECTF) represents, co-ordinates and promotes a unique concentration of complementary expertise in tropical forests as well as an extensive breadth of experience in subtropical and temperate forests. Members work towards the ECTF goal through strategic and applied research, professional and technical training, graduate and post-graduate education and institutional strengthening.

www.forestry.gov.uk

The UK Forestry Commission is the government department responsible for the protection and expansion of the UK's forests and woodlands.

www.wrap.org.uk

An association dedicated to the recycling of wood and promotion of waste recycling.

Associations

http://lrbb3.pierroton.inra.fr

Public research laboratory which looks at new processes and developments in wood; some very exciting work, but at time of writing only available in French.

www.wood-works.org

An industry-led initiative, spearheaded by the Canadian Wood Council to promote the increased use of wood in commercial, industrial and institutional construction.

wwwhere.else

www.cwc.ca

The Canadian Wood Council (CWC) is the national association representing Canadian manufacturers of wood products used in construction.

www.bdholz.de

German timber importers.

www.timcon.org

Timcon (Timber Packaging and Pallet Confederation) is the UK's National Trade Association working in the interests of the timber packaging industry – principally manufacturers of timber pallets, cases and crates, and export packers.

www.fira.co.uk

The Furniture Industry Research Association (FIRA) claims to have driven the need for higher standards through testing, research and innovation for the furniture and allied industries.

www.woodforgood.com

One tree is cut, two are planted. Wood for good is about encouraging more people to use nature's own building material.

www.ttf.co.uk

Established in 1892, the Timber Trade Federation (TFF) is the leading trade association for timber and is recognised in the UK and overseas as the voice of the timber industry.

www.trada.co.uk

The Timber Research and Development Association (TRADA) is an internationally recognised centre of excellence on the specification and use of timber and wood products.

www.apawood.org

Information on engineered wood products.

www.bwf.org.uk

The British Woodworking Federation (BWF) is recognised as the voice of the woodworking industry and builders' joinery and represents manufacturers of doors, windows, conservatories, staircases, architectural joinery, timber frame buildings and engineered timber components.

www.apa-europe.org

The Engineered Wood Association is one of the world's foremost authorities in engineered wood products. This site is specifically designed for the UK and Irish construction industry. It is also the website for the American Plywood Association.

www.iwsc.org.uk

The Institute of Wood Science exists for all those who care for and have an interest in timber and wood-based products. In conjunction with a number of colleges and training agencies in the UK and Ireland the Institute organises courses in wood technology and utilisation and awards appropriate qualifications.

www.timberweb.co.uk

An e-market where buyers and sellers meet to make timber contracts, improve turnover and promote their business.

www.woodbureau.co.uk

Promotes a better understanding of wood as a basic fibre, common and vital to many and varied industries, to encourage a rational approach to the utilisation of both wood fibre and forest resources.

Suppliers

www.goodtimber.com

For woodturners, carvers, specialist furniture makers, craftworkers, and anybody else who uses wood! Timber cut and prepared to specification.

www.brooksbrosfortimber.co.uk

Timber supplier of any quantity whether it be large or small; random stock or selected to cutting specifications.

www.silverman.co.uk/products/fp02.htm

UK's leading importer and distributor of panel products.

www.championtimber.com

Specialists in supplying quality timber and related products to the building industry, business community and DIY enthusiast.

www.clarkswood.com

Importers of hardwood, softwood and sheet materials.

Design directory

www.pwlimited.co.uk

www.hivespace.com

www.avad.net/avadopen.htm

www.twelvelimited.com

www.schmidingermodul.at

www.bonaldo.it

www.isokonplus.com/interface.htm

www.harveymaria.co.uk

www.paulcarruthersdesign.co.uk

www.jghdesign.co.uk

www.mallinson.co.uk

www.gazeburvill.com

www.berrychairs.co.uk

www.lee-international.com

www.intospace.co.uk

www.taskworthy.co.uk

www.rajko.net

www.gtdesign.it/index2.htm

www.lloydloom.com

www.coexistence.co.uk

www.marinerurbanista.com

www.dan-form.dk

www.tomschneiderdesigns.co.uk

www.attic2.co.uk/welcomeflash.htm

www.tablewithcrossedlegs.co.uk

156

WITHDRAWN

pp6–7 Balsa wood surfboard with thanks and acknowledgement to Melissa Harbour, photography by Daniel Hennessy; p8 Steam-bent Chair, with thanks and acknowledgement to Marc Newson; pp16–17 Byron Armchair and Fara Sideboard, with thanks and acknowledgement to Philipp Mainzer; p18 Altar Furniture, with thanks and acknowledgement to Debbie Wythe; p19 Momentos Bureau, with thanks and acknowledgement to KC Lee; p20 Chair with Holes, with thanks and acknowledgement to Gijs Bakker; p21 Shuttle Office Furniture, with thanks and acknowledgement to The Gunlocke Company; pp22–23 The Rockable and The Unrockable, with thanks and acknowledgement to Hans Sandgren Jakobsen; p24 Eighteen Cabinet, with thanks and acknowledgement to John Makepeace; p25 Whole Chair, with thanks and acknowledgement to David Landess; p26 Weeds, Aliens and Other Stories, with thanks and acknowledgement to Anthony Dunne, Fiona Raby and Michael Anastassiades; p27 Teak Garden Furniture, with thanks and acknowledgement to the Modern Garden Furniture Company; pp28–29 Oak Tree Wall Box, with thanks and acknowledgement to Gill Wilson and the One Tree project, photography by Robert Walker; p30 Portable Orange Peeler, with thanks and acknowledgement to Marti Gruixé and Droog Design; p31 Split-willow Frame Basket, photography by Xavier Young; pp32–33 Balsa Wood Surfboard with thanks and acknowledgement to Melissa Harbour, photography by Daniel Hennessy; p34 Jelutong models of design classics, with thanks and acknowledgement to Giovanni Sacchi; p35 Hickory Crook, with thanks and acknowledgement to James Smith; p36 Cheese Grater from the Twergi Collection, with thanks and acknowledgement to Alessi; p37 Lignum Vitae Sample, photography by Xavier Young; p38 Klick Candle-holder, with thanks and acknowledgement to Anna Frohm, photography by Xavier Young; 39 Vine Chair, with thanks and acknowledgement to John Makepeace; pp42–43 Ivar Basic Unit and Sten Shelving Unit, with thanks and acknowledgement to Ikea; pp44–45 Xylo Sideboard, with thanks and acknowledgement to Ben Panayi; pp46–47 Pencil production, photography by Xavier Young; p49 Spruce Viol, with thanks and acknowledgement to Jane Julier; pp50–51 Shoetree, with thanks and acknowledgement to Dunkelman & Sons, photography by Xavier Young; pp54–55 Power Play Chair and Footstool, with thanks and acknowledgement to Frank Gehry; p56–57 10.2lbs Table from the Multi-Ply Series, with thanks and acknowledgement to Foundation 33; p58 Flexiply™ Sample, with thanks and acknowledgement to the Tambour Company, photography by Xavier Young; p59 Pre-cut Flexible MDF sample, with thanks and acknowledgement to Neat Concepts Ltd., photography by Xavier Young; pp60–61 Multi-Ply™ Samples, with thanks and acknowledgement to Tin Tab Ltd., photography by Xavier Young; p62 Propeller Blade, with thanks and acknowledgement to Permali Dehoplast Ltd.; p63 3pli®, Cristal de Ravier® and Arcane® Samples, with thanks and acknowledgement to Ravier; pp64–65 Hob-Nob Biscuit Children's Furniture, with thanks and acknowledgement to Michael Marriott,

Simon Maidmont and Oreka Kids; pp66–67 Hammer, with thanks and acknowledgement to Thor Hammer; pp68–69 Lalegerra Chair, with thanks and acknowledgement to Ricardo Blumer; pp70–71 Skateboard, with thanks and acknowledgement to Skate of Mind; pp74–75 Gardening Bench, with thanks and acknowledgement to Droog Design; pp76–77 Straw Bowls, with thanks and acknowledgement to Kristiina Lassus and Alessi; pp78–79 Cork Chair, with thanks and acknowledgement to El Ultimo Grito; pp80–81 Coconut Fibre Board, photography by Xavier Young; pp82–83 Chasen Tool, photography by Xavier Young; p84 Charcoal, photography by Xavier Young; p85 Chewing Gum, photography by Xavier Young; p86 Plastic Wood Composite Samples, photography by Xavier Young; p87 Veneer Samples, with thanks and acknowledgement to Alpi; pp90–91 Wooden Wallpaper, with thanks and acknowledgement to Gilford, photography by Xavier Young; pp92–93 Jean Maie Tjibaou Cultural Center, with thanks and acknowledgement to Renzo Piano Building Workshop; pp94–95 Paralam Sample, with thanks and acknowledgement to Trus Joist, photography by Xavier Young; pp96–97 Steko Block, with thanks and acknowledgement to Construction Resources, photography by Xavier Young; pp98–99 Hooke Park College, with thanks and acknowledgement to The Parnham Trust; pp100–101 Glulam Structure, with thanks and acknowledgement to the Glued Laminated Timber Association; pp102–103 Weald and Downland Gridshell Workshop, with thanks and acknowledgement to the Weald and Downland Open Air Museum; p106 Jim Nature Television, with thanks and acknowledgement to Philippe Stark; p108 Bendywood, with thanks and acknowledgement to Mallinson; p109 Stool 60, with thanks and acknowledgement to Alvar Aalto; pp110–111 Steam-bent Chair, with thanks and acknowledgement to Marc Newson; pp112–113 Jaguar X Type interior, with thanks and acknowledgement to Jaguar; pp114–115 CNC-processed Sample, with thanks and acknowledgement to Haldane (UK) Ltd.; pp116–117 Friedman Toothpicks, photography by Xavier Young; pp118–119 LCW Chair, with thanks and acknowledgement to Charles and Ray Eames. © 2002 Eames Office; Schizzo Chair, with thanks and acknowledgement to Ron Arad; p120 Red Ivory Sample, photography by Xavier Young; p121 Pipe with Billiard-shaped Bowl and Windshield, with thanks and acknowledgement to Dunhill, photography by Xavier Young; pp122–123 Eclipse Laundry Bin, with thanks and acknowledgement to Christopher Laughton; pp124–125 Sliding Chair, with thanks and acknowledgement to Yann Gafsou; p126 Pressed Laminated Tray, with thanks and acknowledgement to Neville UK, photography by Xavier Young; p127 Bademuschel Bathtub, with thanks and acknowledgement to Tilo Gnausch; pp128–129 Matches, photography by Xavier Young; pp130–131 Concents Wooden Socket, with thanks and acknowledgement to Koichi Futatsumata, photography by Xavier Young; pp136–148 Wood samples, with thanks and acknowledgement to the Wood Bureau; pp150–151 Japanese Drum, with thanks and acknowledgement to Asano Taiko.

Thank you

To Laura Owen and Nicole Mendelsohn at RotoVision, thank you so much for your immense help, cheeriness and for helping me get through this book in a reasonable state of mind. Thanks to Aidan Walker for his suggestions and reference material. To Becky Moss once again, thanks for your support and guidance; it's a real pleasure working with you.

Thanks to John Park for his constant advice and Paul Sayers for letting me loose on his invaluable collection of books. To Dan Dimant, Mark Greene and Jackie Piper for their ideas and suggestions. Andy Ellis and Sebastian Frith for their enthusiastic input on skateboards. To Nick Rhodes and Jamie Brassett for their feedback. To Simon Bolton for his enthusiastic support of the whole Materials series. To Jim Sullivan at CSM and Chris Whaite, formerly furniture tutor at CSM, for his invaluable help and suggestions when this book was just a seedling.

Thanks to Marco Yip and Alison Lam for their help with images and for Marco's constant offerings of Chinese wooden artefacts.

Thanks to Michael Lee at the BWF and to the TTF for the technical pages. To Phil Norsworthy at Dunkelmans for the shoetree, the staff at James Smith for their walking stick contribution, Derek Mathers at Thor Hammer and Guidio at Skate of Mind.

And of course, to my wife Alison for her thousands of ideas, suggestions and constant enthusiasm.

Index